T Company

The Dark Things

by Ursula Rani Sarma

First performed on 6 October 2009
at the Traverse Theatre, Edinburgh

Cast

Daniel Brian Ferguson
LJ Suzanne Donaldson
Steph Nicola Jo Cully
Gerry David Acton
Karl Keith Fleming

Director Dominic Hill
Designer Neil Warmington
Lighting Designer Lizzie Powell
Sound Designer John Harris

Company Stage Manager Gemma Smith
Deputy Stage Manager Dan Dixon
Assistant Stage Manager Kirsty Louise Airlie
Wardrobe Supervisor Sarah Holland

Company Biographies

David Acton (*Gerry*)

David trained at Webber Douglas. Theatre credits include seasons at Bolton, Durham, York, Basingstoke, Southampton and Cherub Company. *Hamlet* (Oxford Playhouse); *The Clandestine Marriage* (Bristol Old Vic); *Romeo And Juliet* (Chester Gateway); *All My Sons* (Watford Palace Theatre); *Romeo And Juliet, A Midsummer Night's Dream* (AFTLS USA Tours); *Twelfth Night, Othello, Henry V, The Comedy Of Errors, A Midsummer Night's Dream* (Propeller, Newbury Watermill and International Tours); *Down By The Greenwood Side* (Donmar Warehouse); *King Lear* (Young Vic, Leicester Haymarket & Tokyo Globe); *Caesar And Cleopatra* (Greenwich Theatre); *Celaine* (Hampstead Theatre); *The Constant Couple, Man Of Mode, King Lear, Hamlet, The Comedy Of Errors, The Love Of The Nightingale, As You Like It, Henry V, The Comedy Of Errors; Edward III, Eastward Ho!, The Roman Actor* (RSC); *Breaking The Code* (Northampton); *Celestina* (Birmingham Rep/Edinburgh International Festival); *Much Ado About Nothing* (Peter Hall Co); *Copenhagen* (Newbury Watermill); *Richard II* (Old Vic Co); *I Have Been Here Before, Vertigo* (Nottingham Playhouse); *Burial At Thebes* (Nottingham Playhouse/Barbican), *One Night In November* (Coventry Belgrade), *Sabbat, Jason And The Argonauts* (The Dukes Lancaster). Television credits include *Eastenders; I Love Keith Allen; All In The Game; So Haunt Me; Persuasion; Casualty; Randall And Hopkirk (Deceased); The Wyvern Mystery; Macbeth; Fooling Hitler; Casanova's Love Letters; Class Of '76; Blair On Trial; Doctors; Tchaikovsky; The Bill; Hollyoaks; Passage*. Radio includes *Manikudlak And The Bear; Into Exile; Strangers And Brothers; Silver Street; Death Of A Secret Wife*.

Nicola Jo Cully (*Steph*)

Nicola Jo trained at Queen Margaret University College, Edinburgh. Theatre credits include: *The Prime Of Miss Jean Brodie (Royal & Derngate, Northampton and Assembly); Sunshine On Leith* (Dundee Rep); *The Wasp Factory* (Cumbernauld Theatre Company); *Translations* (Arches Theatre); *The Journey Of Jeannie Deans* (Rowan Tree); *My Dark Sky* (Reeling and Writhing); *Sinbad* (Team Entertainments/Eden Court); *3 For 2* (P & F Productions); *Tenko* (Random Act Theatre Company); *The Prime Of Miss Jean Brodie* (Royal Lyceum Theatre, Edinburgh); *Blude Red – The Musical* (Cutting Edge Theatre Company). Film credits include: *Retribution* (The Film Development Partnership); *Tough* (Blue Iris/Napier Screen); *Solid Air* (Elemental Films); *Nowhere No-One* (Marquisde Ltd); *Little Red Hoodie* (Imagine Films); *The Charm*. Television credits include: *Taggart* (STV) and *Witchcraze* (Blast Films). Radio includes: *Desperate Measures* (BBC Radio Scotland/Radio 4). Film credit: *The Space Between* (Lyre Productions).

Suzanne Donaldson (*LJ*)

For the Traverse: *Dark Earth*. Other theatre includes: *Mary Massacre* (Harbour Arts Centre); *Peter Pan* (Visible Fictions); *The Snow Queen, A Streetcar Named Desire, Sinbad And The Lost Princess* (Perth Theatre); *Flouers O Edinburgh, Taking Sides, The Magistrate* (Pitlochry Festival Theatre); *The Merchant Of Venice* (Royal Lyceum Theatre, Edinburgh); *Whiskey Galore* (Cutting Edge); *No Mean City, Baby Doll, A Handful Of Dust, The Borrowers* (Citizens Theatre); *Jack And The Beanstalk* (Kilmarnock Theatre); *Behind Office Doors, Tarot Reader* (Oran Mor); *Three Thousand Troubled Threads* (Stellar Quines). Radio credits include: *Catch My Breath, The Observations* (BBC). Short Film: *Samantha*.

Brian Ferguson (*Daniel*)

Brian trained at RSAMD. For the Traverse: *Fall*, *Rupture* (co-production with National Theatre of Scotland). Other theatre credits include *The Drawer Boy*, *Love Freaks* (Tron Theatre); *They Make These Noises*, *Spanglebaby* (Arches Theatre Company); *Snuff* (Arches Theatre Company/National Theatre of Scotland); *Black Watch* (National Theatre of Scotland); *Falling* (Poorboy/National Theatre of Scotland); *Particularly In The Heartland* (The TEAM); *Bridgebuilders* (Poorboy); *Decky Does A Bronco* (Grid Iron); *Observe The Sons Of Ulster* (Citizens Theatre); *She Stoops To Conquer* (Perth Theatre). Film & Television credits include *Doctors*, *One Minute Drama: The Prayer*, *Black Watch*, *River City* (BBC); *Voices* (Phase IV Productions); *Taggart: Island* (SMG); *Still Game* (Comedy Unit / BBC); *Overnite Express* (Square GO Productions / BBC); *Last Legs* (Stella Maris Films / STV); *Rockface* (Union Pictures/BBC). Radio includes *Black Watch* and *Taglines* (BBC).

Keith Fleming (*Karl*)

Theatre credits include: *Barflies* (Grid Iron – Fringe First & Herald Angel Award-winning production); *Peer Gynt* (Dundee Rep Theatre/National Theatre of Scotland – joint Best Actor Critics' Award for Theatre in Scotland); *Sunshine On Leith*, *A Midsummer Night's Dream*, *Monkey*, *A Lie Of The Mind*, *Macbeth*, *Rum And Vodka*, *Scenes From An Execution*, *The Danny Crow Show*, *Twelfth Night*, *A Night Before Christmas*, *A Winter's Tale*, *Dancing At Lughnasa*, *Cabaret*, *Mince?*, *Pants* (Dundee Rep); *If Destroyed True* (Dundee Rep/Paines Plough). Film and television credits include: *Split Second* (BBC Screen One); *Kings Of The Wild Frontier* (Newfoundland/Scottish Television).

John Harris (*Composer / Sound Designer*)

John trained at RSAMD and Oxford University. For the Traverse: *The Last Witch* (co-produced with the Edinburgh International Festival), *Lucky Box* (co-produced with Oran Mor), *Nobody Will Ever Forgive Us*, *Nasty Brutish And Short*, *The Dogstone* (all co-produced with National Theatre of Scotland), *The Nest*, *Knives in Hens*, *Anna Weiss*, *Family*, *Perfect Days*, *Greta*, *Sharp Shorts*, *Kill The Old Torture Their Young*. Other theatre credits include: *Monaciello* (Tron / Naples International Theatre Festival); *Julie*, *Mary Queen Of Scots*, *Gobbo* (National Theatre of Scotland); *Mother Courage*, *Jack And The Beanstalk* (Dundee Rep); *Jerusalem* (West Yorkshire Playhouse); *Midwinter*, *Solstice* (Royal Shakespeare Company). Opera includes *Death Of A Scientist* (Scottish Opera), *Sleep Sleep*, *The Sermon* and *Who Is She?* (all Tapestry Opera Briefs, Toronto). Film and TV credits include *The Fingertrap* (BAFTA Scotland Emerging Talent Award 2009); *Saltmark* (Blindside); *The Emperor, The Green Man Of Knowledge* (Red Kite). John writes concert music. He also directs the Red Note Ensemble. He was for several years assistant organist at St Giles' Cathedral, Edinburgh.

Dominic Hill (*Director*)

Dominic became Artistic Director of the Traverse Theatre in January 2008. Before joining the Traverse, Dominic was Artistic Director of Dundee Rep Theatre from 2003 – 2007. For the Traverse: *The Last Witch* (co-produced with the Edinburgh International Festival), *Kyoto* by David Greig, *Lucky Box* by David Harrower (both co-produced with Oran Mor), *The Dogstone* by Kenny Lindsay, *Nasty, Brutish And Short* by Andy Duffy (both co-produced with National Theatre of Scotland) and *Fall* by Zinnie Harris. Productions for Dundee Rep Theatre include *Peer Gynt* (co-produced with National Theatre of Scotland, winner of Best Director and Best Production, Critics Awards for Theatre in Scotland 2008), *Happy Days*, *Hansel And Gretel*, *Midsummer Night's Dream*, *Monkey*, *The Talented Mr Ripley*, *Ubu The King*, *The Graduate*, *Macbeth*, *Scenes from An Execution* (winner of Best Director and Best Production, Critics Awards for

Theatre in Scotland 2003), *Peter Pan, Twelfth Night, Dancing At Lughnasa, The Snow Queen, The Duchess Of Mafia* and *The Winter's Tale* (nominated for Best Director, Barclays/TMA Awards). For Scottish Opera: *Falstaff* and *Macbeth*. For the Young Vic: *A Prayer For My Daughter*.

Lizzie Powell (*Lighting Designer*)

Lizzie trained at the Royal Academy of Music and Dramatic Arts. For the Traverse: *Cockroach, The Dogstone, Nasty, Brutish And Short, Nobody Will Ever Forgive Us, Rupture* (all co-produced with National Theatre of Scotland). Other theatre lighting design includes: *Transform Glasgow, Transform Orkney, Mary Queen Of Scots Got Her Head Chopped Off, Our Teacher's A Troll, Venus As A Boy, The Recovery Position, Oedipus, Home: Edinburgh* (National Theatre of Scotland); *First You're Born* (Plutôt la Vie); *Pobby & Dingan, The Book Of Beasts* (Catherine Wheels); *Under Milk Wood* (Theatre Royal, Northampton); *The Death Of Harry, Making History* (Leon Ouroborous Productions, Dublin); *The Wasp Factory, Jack & The Beanstalk* (Cumbernauld Theatre); *The Wall* (Borderline Theatre); *Great Expectations* (Prime Productions); *Travels With My Aunt* (New Wolsey Theatre); *Father Matthew* (Yew Three Productions/Cork Opera House); *Smallone, Romeo & Juliet, The Ebony Bird, Tricky* (Blood In The Alley Productions); *Drenched* (Boiler House Productions – Nominated Best Design, Manchester Evening News Awards); *The Night Shift, Vanity Play* (Fuel Productions); *The Foolish Man* (Grass Market Product); *How To Kill (Your Lover)* (Theatre Objektiv); *Bones* (Mama Quillo); *Second City Trilogy* (Cork Opera House); *The Cudgel & The Rapier, Crave, Patching Havoc, Cowboy Mouth* (Liquid Theatre Company); *A Comedy Of Errors* (Wild Thyme Productions); *Howie The Rookie* (Fourth Road). Assistant Lighting Designer on *The Evocation of Papa Mas*, (Told By An Idiot, national tour, 2006). Assistant to the Lighting Designer on *Billy Elliot* at the Victoria Palace Theatre London, 2005. Production Assistant with Theatre de Complicite 2002 – 2004. Artistic Director of Blood In The Alley Theatre Company, Ireland. Member of ALD (Association of Lighting Designers).

Ursula Rani Sarma (*Writer*)

Ursula Rani Sarma is an award-winning writer of Irish/Indian descent. She has written for companies such as The National Theatre London, The Abbey Theatre Dublin, Paines Plough Theatre London and The Stephen Joseph Theatre Scarborough amongst others. Her plays include: *Birdsong* (The Abbey Theatre), *The Parting Glass* (Origin Theatre New York), *The Magic Tree* (Djinn Theatre/CMF/Belltable); *The Spider Men* (National Theatre, London); *When the War Came* (New Theatre Company); *Orpheus Road* (Paines Plough); *Gift* (Belltable); *Blue* (The Cork Opera House); *Touched* (Djinn/Granary). Her work has been translated and produced in countries such as Germany, the Netherlands, Switzerland, Romania, Italy and France. Ursula has received many awards for her plays including an Irish Times/ESB Theatre Award and an Edinburgh Fringe Award. Ursula's plays for radio include *Car Four* and *A Tiny Light In The Darkness* for the BBC and *The Fishermen* for RTE. Her screenplays include *Breaking Into Houses and Stealing Things* (B3Media/Film4), *Brothers Of Burma* (LeBrocquyFraser) and *Raw (Ecosse Films)*. A selection of her poetry is included in anthologies published by Arlen Press and Dedalus Press. Ursula is currently developing several projects for the stage and screen including new play *Riot* for the ACT San Francisco premiering in April 2010 and *Wild Horses* for The Stephen Joseph Theatre Scarborough. *The Dark Things* is Ursula's first commission for the Traverse Theatre.

Neil Warmington (*Designer*)

Neil trained on the Motley Theatre Design Course and also holds a degree in Fine Art from the Maidstone College of Art. For the Traverse: *Solemn Mass For A Full Moon In Summer, Family, Passing Places, King of the Fields, Gagarin Way,*

Slab Boys Trilogy (Traverse/National Theatre). Other theatre design includes *The Cherry Orchard, Balgay Hill, Romeo And Juliet, Jack And the Beanstalk, Sunshine On Leith, If Destroyed True, Gypsy, Scenes From An Execution, Dumbstruck, Lie Of The Mind* (Dundee Rep); *Mary Stuart, Elizabeth Gordon Quinn* (National Theatre of Scotland); *The Straits, The Drowned World, Splendour, Riddance, Crazy Horse, The Small Things, Pyrenees* (Paines Plough); *King Lear* (English Touring Theatre/Old Vic); *Ghosts, Don Juan, John Gabriel Borkman, Taming Of The Shrew, Love's Labours Lost* (English Touring Theatre); *Woyzeck, The Glass Menagerie, Comedians,* Tankred Dorst's *Merlin* (Royal Lyceum Edinburgh); *Angels In America* (7:84); *Life's A Dream, Fiddler On The Roof, Playhouse Creatures* (West Yorkshire Playhouse); *Henry V* (RSC); *Much Ado About Nothing* (Queen's London); *Sunset Song, Mary Queen Of Scots Got Her Head Chopped Off* (Theatre Royal, Glasgow); *The Life Of Stuff* (Donmar); *Waiting For Godot* (Liverpool Everyman); *The Tempest* (Contact); *Jane Eyre, Desire Under The Elms* (Shared Experience); *Troilus & Cressida* (Opera North); *Oedipus Rex* (Connecticut State Opera); *The Marriage Of Figaro* (Garsington Opera); *Knives In Hens, The Birthday Party* (TAG). Neil has also won three TMA Awards for best design, worked as the designer on numerous Edinburgh Fringe First-winning productions and has been awarded the Linbury Prize for stage design, and the Sir Alfred Munnings Florence Prize for painting.

Traverse Theatre

Artistic Director Dominic Hill

The Traverse has an unrivalled reputation for producing contemporary theatre of the highest quality, invention and energy, and for its dedication to new writing.
(Scotland on Sunday)

The Traverse is Scotland's New Writing Theatre. From its conception in the 1960s, it has embraced a spirit of innovation and risk-taking that launched the careers of many of Scotland's best-known writers including John Byrne, David Greig, David Harrower and Liz Lochhead. It is unique in Scotland in that it fulfils the crucial role of providing the infrastructure, professional support and expertise to ensure the development of a dynamic theatre culture for Scotland.

The Traverse Theatre, the festival's most prestigious home of serious drama.
(New York Times)

The Traverse is a pivotal venue in Edinburgh. It receives enormous critical and audience acclaim for its programming, as well as regularly winning awards. In 2009, *Pornography* by Simon Stephens was awarded Best New Play at the Critics Awards for Theatre in Scotland making it the second consecutive win for a Traverse production with Alan Wilkins' *Carthage Must Be Destroyed* picking up the award in 2008. From 2001–09, Traverse productions of *Gagarin Way* by Gregory Burke, *Outlying Islands* by David Greig, *Iron* by Rona Munro, *The People Next Door* by Henry Adam, *Shimmer* by Linda McLean, *When the Bulbul Stopped Singing* by Raja Shehadeh, *East Coast Chicken Supper* by Martin J Taylor, *Strawberries in January* by Evelyne de la Chenelière in a version by Rona Munro, *Damascus* by David Greig and *Orphans* by Dennis Kelly have won Fringe First or Herald Angel awards (and occasionally both). Most recently, the Traverse's 2009 Festival programme picked up an incredible twenty-one awards including seven Scotsman Fringe Firsts and five Herald Angels.

A Rolls-Royce machine for promoting new Scottish drama across Europe and beyond.
(The Scotsman)

The Traverse's success isn't limited to the Edinburgh stage. Since 2001 Traverse productions of *Damascus, Gagarin Way, Outlying Islands, Iron, The People Next Door, When the Bulbul Stopped Singing,* the *Slab Boys Trilogy, Mr Placebo* and *Helmet* have toured not only within Scotland and the UK, but in Sweden, Norway, the Balkans, the Middle East, Germany, USA, Iran, Jordan and Canada. In 2009 the Traverse toured its production of *Midsummer* by David Greig and Gordon McIntyre to Ireland and Canada.

The Traverse has done Edinburgh proud.
(The Observer)

The Traverse's work with young people is of supreme importance and takes the form of encouraging playwriting through its flagship education project *Class Act*, as well as the Young Writers' Group. *Class Act* is now in its 20th year and gives school pupils the opportunity to develop their plays with professional playwrights and work with directors and actors to see the finished piece performed on stage at the Traverse. The hugely successful Young Writers' Group is open to new writers aged 18 – 25 with fortnightly meetings led by a professional playwright. Last Autumn the Traverse worked for the first time with young men from HM Young Offenders Institution Polmont to improve their literacy skills through practical drama and playwriting in a project called *OutWrite*. The participants worked with theatre professionals to develop their own plays which were performed both at HM YOI Polmont and at the Traverse.

The importance of the Traverse is difficult to overestimate...without the theatre, it is difficult to imagine Scottish playwriting at all.
(Sunday Times)

The Traverse is committed to working with international playwrights and in 2005 produced *In the Bag* by Wang Xiaoli in a version by Ronan O'Donnell, the first ever full production of a contemporary Chinese play in the UK. This project was part of the successful Playwrights in Partnership scheme, which unites international and Scottish writers, and brings the most dynamic new global voices to the Edinburgh stage. Other international Traverse partnerships have included work in Québec, Norway, Finland, France, Italy, Portugal and Japan.

To find out about ways in which you can support the work of the Traverse please contact Fiona Sturgeon Shea, Head of Communications on 0131 228 3223 or fiona.sturgeonshea@traverse.co.uk www.traverse.co.uk

Support for the Traverse

We would like to thank the following corporate sponsors for their support:

 SCO++ +CO

 New Arts Sponsorship Grants
Supported by the Scottish Government
In conjunction with
A&B
Arts & Business Scotland

 STEWARTS

 Scottish & Newcastle UK

 Red Noman

 smg tv productions

 sky

 LUMISON

 ALLIANCE WINE

 pinnacle communications

 BAIRDS fine and country wines

To find out how you can benefit from being a Traverse Corporate Sponsor,
please contact Fiona Sturgeon Shea, Head of Communications
on 0131 228 3223 / fiona.sturgeonshea@traverse.co.uk

The Traverse Theatre's work would not be possible without the support of

 Scottish Arts Council BRITISH COUNCIL 75 YEARS OF CULTURAL RELATIONS ·EDINBVRGH· THE CITY OF EDINBURGH COUNCIL

 Playwrights' Studio, Scotland

Emerging Playwright on Attachment post supported by Playwrights Studio
Scotland as a Partnership Project

Pearson playwright supported by **Pearson**

For their help on *The Dark Things* the Traverse thanks
Carter Ferguson, Fight Director
Anne Goeswell for Pole Dancing Lessons www.goeswell.co.uk
British Red Cross
Siobhan Gray
J. Dunsmore Recovery and Salvage
Rachel at Sutcliffe Play
John at Fix Price Garage
Anderson Medical and Mobility
Tron Theatre, Glasgow
Citizens' Theatre, Glasgow

Are You Devoted?

Our Devotees are: Joan Aitken, Stewart Binnie, Katie Bradford, Adrienne Sinclair Chalmers, Lawrence Clark, Adam Fowler, Joscelyn Fox, Anne Gallacher, Caroline Gardner, John Knight OBE, Iain Millar, Gillian Moulton, Helen Pitkethly, Michael Ridings, Bridget Stevens, Walton & Parkinson

The Traverse could not function without the generous support of our patrons. In March 2006 the Traverse Devotees was launched to offer a whole host of exclusive benefits to our loyal supporters

Become a Traverse Devotee for £29 per month or £350 per annum and receive:

- A night at the theatre including six tickets, drinks and a backstage tour
- Your name inscribed on a brick in our wall
- Sponsorship of one of our brand new Traverse 2 seats
- Invitations to Devotees' events
- Your name featured on this page in Traverse Theatre Company scripts and a copy mailed to you
- Free hire of the Traverse Bar Café (subject to availability)

Bricks in our wall and seats in Traverse 2 are also available separately. Inscribed with a message of your choice, these make ideal and unusual gifts.

To join the Devotees or to discuss giving us your support in another way, please contact Fiona Sturgeon Shea, Head of Communications on 0131 228 3223 / fiona.sturgeonshea@traverse.co.uk

The Traverse Theatre receives financial assistance from:

The Atlantic Philanthropies, The Barcapel Foundation, The Misses Barrie Charitable Trust, The Binks Trust, The Craignish Trust, The Cross Trust, The Cruden Foundation, The Imlay Foundation, James Thom Howat Charitable Trust, The John Thaw Foundation, The Lloyds TSB Foundation for Scotland, The Peggy Ramsay Foundation, The Ronald Duncan Literary Foundation, Sky Youth Action Fund, Tay Charitable Trust, The Thistle Trust, The Weatherall Foundation

For their continued generous support of Traverse productions, the Traverse thanks:
Habitat
Marks and Spencer, Princes Street
Camerabase

Charity No. SC002368

Traverse Theatre – The Company

THE DARK THINGS

First published in 2009 by Oberon Books Ltd
521 Caledonian Road, London N7 9RH
Tel: 020 7607 3637 / Fax: 020 7607 3629
e-mail: info@oberonbooks.com
www.oberonbooks.com

A catalogue record for this book is available from the British
Library.

ISBN: 978-1-84002-963-5

Cover photograph by Euan Myles

Printed in Great Britain by CPI Antony Rowe, Chippenham.

Characters

DANIEL
LJ
STEPH
GERRY
KARL

15

ACKNOWLEDGEMENTS

Many thanks to; Katherine Mendelsohn, Mike Griffiths, Louise Stephens and all at the Traverse theatre; to the cast and crew who worked so hard and made the first production so memorable.

As always, sincere thanks to Mel Kenyon and all at Casarotto Ramsay.

Thanks to my mother Frances for everything, and to Susmita and Kiran.

Thanks also to John Tiffany, Philip Howard, Amit Kamboj, Siobhan Coyne, Fiona O'Loughlin and all at Oberon Books.

Finally, I would like to extend my sincere thanks and appreciation to Dominic Hill, for bringing *The Dark Things* to life. It has been a wonderful adventure.

SCENE ONE

Darkness. We hear DANIEL's voice. As the light builds it reveals him standing in a wasteland. Despite the change of setting from scene to scene, the wasteland is present at all times. Broken bus fragments litter the floor. Large sheets of dull and torn metal are strewn here and there. A lone burnt shoe sits somewhere and a child's school bag somewhere else. DANIEL is in his twenties. He is earnest, intense, and lost.

DANIEL: Darkness. (*Beat.*) Total and complete darkness.
(*Beat.*) Oceanic darkness (*Beat.*) Like being at the bottom
of a lake, on your back, stuck fast in the mud and sinking
(*Beat.*) Trying to breathe, trying to decide if I am alive
or dead, try telling myself it's a dream and will myself to
wake up and see...and see...my bedside table...yellow
lamp...floral sheets (*Beat.*) comforting (*Beat.*) No. (*Beat.*)
Then tell myself I'm drowning because I know that
feeling...drowning...this...being...crushed, lungs being
crushed, collapsing, no air, stuck fast in the mud and...
drowning. (*Beat.*) Before...there was a woman beside
me, bright coloured clothes, baby strapped to her chest,
smiling, happy, made me smile without meaning to. (*Beat.*)
There was a girl by the door with long red hair and her
face was covered in freckles...and her skin...looked like
porcelain...pale...translucent. She was very thin...looked
like she could break easily...delicate...made me want to
protect her. (*Beat.*) In that heat...everything seemed that
little bit more...intense and colourful and I smiled at this
red haired girl and she smiled back and the city didn't feel
like a city, it felt like we all wanted the same things in the
end...and it was a good feeling...warm and comforting
and good and then (*Beat.*) Darkness. (*Beat.*) Metal scraping
and collapsing and the bus seats buckling and people
screaming. (*Beat.*) My eyes closing and not re-opening.
(*Beat.*) Heaving...things snapping...breaking...things being
broken...bones...no...yes bones. (*Beat.*) The sound of
bones breaking is...inhuman. I curl up...in a ball...pull my
knees up duck my head down and pray...please God get
me out of this...please God...please fucking God... I don't

care... I don't care if everyone else is crushed to death and I'm... I'm the only one left (*Beat, enter LJ, pretty, in her twenties and in a wheelchair.*)

LJ: Are you done?

DANIEL: (*Reaches forward and turns off a video camera which has been recording him, he is annoyed at being interrupted.*) Almost

LJ: Good... I've a pain in my fucking arse listening to all this 'poor me' shite...let's go for a pint

DANIEL: But I'm not done

LJ: What's left to do?

DANIEL: I don't know

LJ: I can help

DANIEL: No, (*Beat.*) you can't

LJ: Oh (*Beat.*)

DANIEL: I wish you could though, it would be great if you could, it would be easier

LJ: Don't know why they thought it would be a good idea for us to come here, I mean what good is it looking at all this?

DANIEL: They wanted us to feel empowered...to make us realise how lucky we were to walk away from it

LJ: Are you being funny? (*DANIEL looks at her.*) Walk away?

DANIEL: It's a figure of speech

LJ: Tell that to my legs if you see them...maybe I'll have them stuffed...put them on the living room wall beside the telly (*DANIEL looks at her horrified.*) Jesus...relax... I'm only fucking about...face of you...you'd swear they were your legs I was on about... (*She exits.*)

DANIEL reaches forward and switches on the camera.

DANIEL: And then I hear a voice…calling me and it's a familiar voice…it sounds comforting…and it's coming from above…and more than anything… I want to be near that voice. (*Beat.*) And I will myself to move…will my lungs to inflate and push outwards and push upwards… force my bones up towards the voice…towards the light beyond the darkness and beyond the metal scraping bone breaking…and then the voice gets louder and louder until it kind of… (*Relishing the moment.*) wraps itself around me…and it is heat and comfort and safety and home and I – (*LJ enters.*)

LJ: – Danny are you coming or what?

DANIEL: (*Annoyed.*) I said I'm not done (*Beat, looks at her, LJ's face is impossible to read. He softens.*) Alright. (*She doesn't respond, just stares at him.*) Alright.

LJ: (*She softens, but not too much.*) Good then

She wheels herself off, he reaches out and presses stop, he sees something on the ground. It's a toy aeroplane. He picks it up and stares at it. Lights down.

SCENE TWO

DANIEL's flat. The place is in disarray. There are half finished paintings here and there with one particularly large abstract painting somewhere visible. There is a couch with a sleeping bag, newspapers, cups and clothes on the ground. STEPH, early twenties enters. She has a childlike energy, full of naïveté and desperate to be loved. She is wearing pyjamas and holding a carton of orange juice and a box of cornflakes. She eats and drinks from both. She walks over to the abstract painting and stares at it. A cornflake goes down the wrong way and she coughs, spluttering cornflakes and orange juice over the painting. She panics and wipes at it with her sleeve, some of the paint comes off on her pyjamas. She panics. She peers at the painting, it's that abstract that it's not entirely clear if it's made a difference to it. She then squirts a little more orange juice over it and rubs it in. She stands back from it and admires it. She

moves to the couch and picks up a walkman. She puts on the headphones and presses play.

STEPH: (*Listening, then presses pause.*) Today is the first day of the rest of my life (*Presses play listens then presses pause.*) Today is a gift and not a burden (*Presses play listens and then presses pause.*) I am the captain of my own ship of motivation (*Presses play, listens then pauses.*) I am special (*Beat, she likes the sound of the words.*) I am special (*She smiles, presses play then pauses.*) I am special. I am precious. I am motivated (*Takes the earphones off and leaves them on the table.*) I am special, I am precious, I am motivated. (*She looks at the remote control thoughtfully, picks it up and switches on a TV. We hear a day time chat show, she snuggles down into the couch. DANIEL enters, he has a bandage around one arm and is carrying a newspaper. STEPH sees bandage, runs to him fussing.*) Oh my God...oh my God...are you okay? What happened? Did you get mugged? Did you? Where did it happen? Did they get your wallet? Did you report it? I knew you were going to get mugged I had a premonition. I had like a vision this morning and you were being mugged by a big guy who kind of looked like Jimmy Nail. Oh my god... (*Hand over mouth.*) did you get mugged by Jimmy Nail?

DANIEL: No Steph, I didn't get mugged by Jimmy Nail

STEPH: (*Looks at him suspiciously.*) Are you sure?

DANIEL: I'm sure

STEPH: Who mugged you then?

DANIEL: No one, I wasn't mugged

STEPH: Maybe you're concussed, Shirley Spenser was mugged and she couldn't remember her dog's name for weeks and she'd had him since she was six and it's not like it was a hard name I mean his name was Spot and he had like a huge black spot on his –

DANIEL: – I wasn't mugged

STEPH: Then what happened?

DANIEL: I just…fell down some stairs…stop fussing

STEPH: Sorry…sorry… (*Beat, looks at him adoringly.*) I know I'll make you breakfast.

I could make some French Toast like Mum used to make

DANIEL: (*Beat.*) Alright

STEPH: Yeah? Will I make French toast?

DANIEL: That would be nice

STEPH: Great… (*Beat.*) great (*Exits, DANIEL looks about the place disgusted at the mess, he searches for a place to sit down. STEPH reappears.*) Danny?

DANIEL: Yeah?

STEPH: Thing is… I'm not really sure… I mean I'm kind of sure but not completely…how to actually…how to make… French Toast…you want some regular toast instead? I make good toast

DANIEL: No

STEPH: (*Disappointed.*) Oh go on, I make really nice toast

DANIEL: I'm not even hungry… I just said yes because I hadn't had French Toast in… I dunno…years. Look I got you the paper (*Shows her.*)

STEPH: What for?

DANIEL: Accommodation

STEPH: Oh right…shit… I'm in your way… I know I'm in your way I should have gone ages ago I'm sorry… I'm messy and I take up too much room and after all you've been through… I'll go…you know what… I'll just go

DANIEL: No Steph…it's not like that it's –

STEPH: It's like when we were small and I was always hanging about your room and touching your toys and you were always trying to get me to get out…it's like that…isn't it? I'm sorry you know, I am (*Beat.*) I'm sorry…sorry

DANIEL: (*Guilty.*) Stop saying that (*She looks at him.*) stop saying sorry

STEPH: Sorry (*Realises she's said it again.*) oh sorr – (*She clamps her hand over her mouth and shakes her head, she can't help it.*)

DANIEL: (*Looks at her wearily.*) Look you can stay here (*STEPH looks at him hopefully.*) for as long as you want

STEPH: Oh thank you…thank you thank you… I'll be good I swear… I'll be tidy… I'll be Suzy home maker I swear. (*Picks up the paper.*) Nice picture…you look a bit scruffy though…you're going to have to buy posher clothes if you're going to be in the paper… (*She looks at him in adoration.*) God you're famous

DANIEL: Not really

STEPH: You're in the paper. That means you're famous. They only put famous people in the paper. (*DANIEL looks at the painting of the ship and notices something odd, STEPH quickly takes it from him.*) What exactly is this one?

DANIEL: (*Looking up.*) That's the only one you said you liked

STEPH: I did… I do… I'm just not sure…what it is exactly?

DANIEL: How could you like it if you don't know what it is?

STEPH: Is that not what it's all about?

DANIEL: It's a ship…a burning ship…sinking (*STEPH turns her head to one side, DANIEL sees that she can't see it and comes towards her, he gestures towards the painting.*) See? There's the stern

STEPH: What's a stern?

DANIEL: You don't see it?

STEPH: I still like it though… I do…pretty colours

DANIEL: What is that? (*Touches the painting and smells his hand.*) Is that juice?

STEPH: (*Changing the subject.*) That girl called again today

DANIEL: What girl?

STEPH: In the wheelchair, she called about twelve

DANIEL: (*Beat.*) LJ

STEPH: Sorry. LJ. She said she'll be in The Peace Park, (*Beat.*) said she'd wait there for you

DANIEL: For how long?

STEPH: (*Like it's weird.*) Said she'd be there all day, said she'd wait for you…all day

DANIEL: (*Looks at his watch.*) Right… (*Beat, reluctantly.*) I should go (*Beat.*) I'll go (*He puts on his coat and stands by the door.*)

STEPH: You sure you're okay?

DANNY: I'm okay

STEPH: It's just…it's just you seem a bit different

DANIEL: I'm the same as I always was

STEPH: (*Smiles.*) Good… I'm glad (*He exits, she looks about.*) I am the captain of my own ship of motivation (*She picks up the paper.*) I am. (*She puts the paper down and picks up the remote control.*) I…

She turns the volume of the TV up and sits on the couch. Lights down.

SCENE THREE

The park. LJ and DANIEL sit with two takeaway mugs of coffee.

DANIEL: It looks worse than it is

LJ: You just fell over?

DANIEL: Missed a step, it's fine, it was alright actually, didn't hurt. So…what you been doing?

LJ: Nothing

DANIEL: Right

LJ: You?

DANIEL: Nothing…well working…trying to work…but nothing

LJ: Like me. Nothing

DANIEL: (*Beat.*) Sometimes I can just sit there for hours, waiting for something to happen, like being a kid and waiting for your dad to pick you up but he never comes and all the other kids get picked up but you're still sitting there waiting (*Beat.*) It's fucking terrible.

LJ: Not getting picked up from school?

DANIEL: No…just…doing nothing…not being able to do… anything…

LJ: What can't you do?

DANIEL: What?

LJ: What can't you do? I mean I *can't* ride a bike, what can't you do?

DANIEL says nothing, he looks away.

DANIEL: That's not what I meant. (*Beat.*) It's good to see you

LJ: Right

DANIEL: It is, really good (*Beat.*) Doesn't seem like it happened at all sometimes, unless you're around…

LJ: Thought you didn't have a girlfriend

DANIEL: I don't

LJ: A girl keeps answering your phone

DANIEL: My sister, well my half sister, Steph, you met her at the hospital, driving me crazy, her stuff is everywhere, kitchen's in a state, I came home today at four and she was still in her pyjamas, lazing about, talking about breakfast

LJ: If you want her out then chuck her out

DANIEL: (*Beat.*) It's not that simple is it...it's not...she's family and you can't do that to family can you?

LJ: (*Beat.*) I was family when my dad chucked me out

DANIEL: (*Beat.*) I couldn't, the guilt, I just couldn't. That's it with family, you do things...nice things for them...and you want it to make you a good person because you've done something good but it doesn't...because you didn't really want to do it in the first place, you know? (*LJ doesn't respond.*) She needs a hand, otherwise she'll be back home stacking shelves for the rest of her life

LJ: What's wrong with stacking shelves?

DANIEL: Nothing

LJ: Someone has to do it, otherwise you'd reach up for your cornflakes and there wouldn't be any there, would there?

DANIEL: (*Beat.*) I wasn't... I was talking about...about... family...

LJ: Like I said, my dad chucked me out when I was sixteen

DANIEL: (*Looks at her.*) Well my dad died when I was eight

LJ: Wasn't his choice though was it? To leave you? He didn't choose it. (*Beat.*) Did you see the memorial? On the telly? (*DANIEL shakes his head.*) Was awful...just...awful...all the families...wives...kids...husbands...parents...fucking...sad

DANIEL: I couldn't watch it

LJ: I couldn't turn it off (*Beat.*) They rang me today...about the compensation. They reckon I'll get a fair bit...that truck

driver works for some multi billion pound company… makes aeroplanes…that's why the truck was full of them… toy aeroplanes. That is weird isn't it? You're in a bus and a truck crashes into it and the truck is full of toy aeroplanes. There is something weird about that…something…

DANIEL: Ironic

LJ: Weird (*Beat.*) You should have faked something…even whiplash would have got you a few thousand… (*DANIEL just smiles. LJ very serious, she means it.*) I'll give you half what I get if you want

DANIEL: (*Looks at her in shock.*) What?

LJ: If you want it… I don't mind… I don't need that much

DANIEL: (*Smiles.*) Very funny

LJ: (*Fakes a smile, puts her defences back up.*) Yeah…too fucking right…think I'd give a penny away? Might buy you a pint or something

DANIEL: Cheers

LJ: Won't know what to spend it on…won't know what to buy

DANIEL: Sure you will…buy anything you want

LJ: Doesn't buy you happiness though. That's what they say isn't it? Won't buy you happiness

DANIEL: Buy you a nice place to live…a home of your own

LJ: (*Beat.*) Not a home if it's just you. (*Beat.*) Just a place – (*She winces in pain for a second.*)

DANIEL: (*Looks at her.*) You alright?

LJ: Nothing…just a pain in my foot…cramp…

DANIEL: (*Looks at her non existent legs.*) But…

LJ: (*Drinks her coffee.*) I don't know…still feel it…like when I was dancing

DANIEL: You're a dancer?

LJ: Was…

DANIEL: What kind?

LJ: Lap dancer (*DANIEL registers shock.*) What's wrong with that?

DANIEL: Nothing. What was it like?

LJ: Like dancing…for yourself…except there are people watching

DANIEL: Oh…

LJ: I was just a dancer…some of the girls did that but I didn't… alright?

DANIEL: (*Awkward beat.*) Performance art

LJ: Huh?

DANIEL: (*Panicking.*) There are a few people who do that… explore sexuality and intimacy and…it's really…really…

He stops talking, stares off stage.

LJ: What's wrong?

DANIEL: (*Beat.*) What?

LJ: (*She follows his stare.*) Who is she?

DANIEL: She was there, in the hospital, after, her daughter…

LJ: (*She nods.*) Right…well… (*Beat.*)

DANIEL: Maybe we should go and say sorry

LJ: For what? (*Beat.*) Wasn't our fault. Nothing we can do about it. Right?

DANIEL: We could say sorry

LJ: Sorry for what?

DANIEL: Sorry for her loss

LJ: How does that help?

DANIEL: Well it's what people say isn't it? It's what people say to people when someone close to them dies. (*Beat.*) It's what people said to me when my dad died.

LJ: And did it help?

DANIEL: (*Beat.*) No. (*Beat, he looks at her.*) He did choose it. (*LJ looks at him.*) He hung himself in a hotel room about three miles from where we lived. So he did choose to leave me.

LJ: Why?

DANIEL: We don't know…he didn't leave a note. (*Beat, he looks at her.*) I made you something (*He rummages in his bag.*)

LJ: (*In disbelief.*) What?

DANIEL: I was sitting there…trying to work, I was thinking about you and I made you something… (*He takes out a silver chain with an LJ on it and hands it to her, she stares at it in wonder.*) There's a guy I know works with silver so I made you this…not the chain but the LJ… I made the LJ, I think it turned out alright…

LJ: (*Finding it difficult to speak, doesn't know how to respond.*) What you go and do that for?

DANIEL: Don't you like it?

LJ: Yeah…of course I like it but…you made it?

DANIEL: Yeah

LJ: Just like that? You just made this for me? Just like that?

DANIEL: If you don't like it…

LJ: It's beautiful… (*She puts the chain on.*) You know sometimes I think that all this happened just so you and I could meet (*DANIEL isn't listening, he is staring at the mother.*) Danny?

DANNY: Huh?

LJ: (*Disappointed.*) Nothing I just said…thanks. (*Beat.*) For this. (*The necklace.*) I'll never take it off

She looks at him searchingly, he looks in the direction of the mother. Lights down.

SCENE FOUR

Darkness, light up slowly on the untidy office of Dr GERRY MITCHEL, decidedly dishevelled, in his late fifties. GERRY stands staring out his window, looking at the sky through binoculars.

GERRY: I saw you…yes I did I saw you clearly…you were right there so there is no point in hiding now…you were right there (*His phone rings. He looks over at his desk annoyed by the intrusion, then back through the binoculars. The phone stops. He sits at the desk and stares at it. Irritated. He picks up the phone.*) I'm in the middle of something tremendously important. (*He listens.*) What if I don't want to? Well it's my choice isn't it? You can't force someone to say goodbye if they don't want to. (*Beat. Charming suddenly.*) You know what I was thinking? I was just thinking of that time when we went over to that little Italian place and you got sauce all over your shirt and we were laughing…you remember? Laughing? (*No response.*) Don't be angry with me (*Beat.*) You know none of this has been easy for me. (*Beat, he searches for something charming to say.*) What are you wearing? (*Beat.*) Can't you just tell me? I mean not what…not what's underneath…not your… (*Like it's a special word.*) underclothes… I don't want to know about your… (*Like it's a special word.*) underwear…for example (*Beat.*) No I don't want to say goodbye (*Beat.*) You always say you're leaving but you never actually go. Of course I care (*Beat.*) Stay… (*Beat.*) Why don't you stay and we talk about it? (*Beat.*) Let's not…let's not fight…OK? OK? Let's…talk…let's…why don't you tell me something…tell me…what colour are your…underclothes? Because it helps me to know…what kind of blue? (*Beat.*) What colour is the sad kind? Oh, I get it. (*Beat.*) Can't you just – (*Beat, Michael*

hangs up.) Oh (*He hangs up the phone. He returns to the window and is delighted at what he sees.*) There you are…yes there you are… (*DANIEL enters and watches him.*) Beautiful…just beautiful (*DANIEL clears his throat.*) Where did you come from?

DANIEL: Pardon?

GERRY: How did you get in?

DANIEL: The door was open

GERRY: Why didn't my assistant announce you?

DANIEL: Have I come at a bad time?

GERRY: I'm not taking clients

DANIEL: If you're thinking I can't pay I can, I have –

GERRY: I'm not taking clie –

DANIEL: (*Takes out a wallet with notes stuffed into it, GERRY stares.*) I have plenty of money

GERRY looks at the notes, then back at DANIEL.

GERRY: (*Adopts a therapists tone.*) I'm Doctor Mitchel

Extending his hand, DANIEL comes forward hesitantly and shakes it.

DANIEL: Daniel

They stand looking at each other for a moment.

GERRY: (*Indicating for him to sit in either the couch or the chair.*) Won't you…?

DANIEL: (*Moving towards the chair.*) Thanks

GERRY: (*Beat.*) I hope my assistant told you my consultation fee is one hundred and fifty pounds

DANIEL: Your assistant wasn't –

GERRY: Well either way it is, its one hundred and fifty pounds

Awkward moment, DANIEL and GERRY look at each other, GERRY doesn't expect him to pay it.

DANIEL: (*Beat.*) You want me to pay you now?

GERRY: (*Surprised.*) Yes. If…if you like (*GERRY stares at his wallet. DANIEL hands him the money.*) Thanks (*He takes the money and puts it in his pocket.*) Good to get that out of the way I find

He looks up smiling, DANIEL is looking at him slightly confused.

Sorry…coffee? I should have asked you, would you like one?

DANIEL: Am…yes… I guess…

GERRY: (*Picks up the phone and presses a button.*) Michael, could you bring us some coffee thank you? (*He sits back, DANIEL watches him do this with confusion.*) Well then…how can I help you?

DANIEL: I'm not –

GERRY: I'm sorry, milk? Sugar?

DANIEL: J…just milk

GERRY: (*Picks up phone and presses button.*) Just milk in one Michael (*He leans back.*) Please continue…you were saying?

DANIEL: There isn't anyone out there, there is a note on the desk

GERRY: Oh?

DANIEL: It said goodbye

GERRY: (*Beat.*) He's gone? (*Beat, he is shocked.*) He's actually gone?

DANIEL: Yes

GERRY: Oh (*Stands moves towards the window.*) What a…well… you know…it's impossible to keep…good staff

DANIEL: Didn't he tell you he was leaving?

GERRY: Of course (*He turns back to DANIEL, looks at him for a moment before speaking.*) You haven't told me why you're here

DANIEL: I'm aware of your work

GERRY: You are?

DANIEL: I have been for some time

GERRY: Well I'm flattered

DANIEL: David Wrixon is a hero of mine

GERRY: (*Disappointed.*) Oh…you mean my work as a Psychiatrist

DANIEL: Do you do other kinds of work?

GERRY: (*Beat.*) No

DANIEL: Basically I'm an Artist and I've…well I've been having these dreams

GERRY: (*Bored already.*) And you want me to tell you what they mean?

DANIEL: Well…no actually… I know what they mean

GERRY: (*Patronising.*) You mean you think you know what they mean…

DANIEL: No… I mean… I know what they mean…

GERRY: (*Confused, he moves back to the desk.*) Ah… I see…

Writes something down in his notepad.

DANIEL: I've been in…well I've been in a bad accident

GERRY: You look fine

DANIEL: I am… I'm completely fine…well… I've no broken bones or anything…just a few bruises

GERRY: So it wasn't that bad an accident then?

DANIEL: It was…it was a very bad accident. (*Beat.*) It was the bus crash

GERRY: A bus crash… (*Writing it down.*) …right…when was this?

DANIEL: No…not a bus crash…the bus crash

GERRY: (*Looks puzzled…looks up at him…recognises him as the penny drops, shocked.*) Oh… (*In awe.*) oh… (*Sitting back.*) oh…you're the guy… I recognise you now…from the paper…you've cut your hair…and you look…different. (*He stares at him, DANIEL looks away.*) The only one eh?

DANIEL: There's another

GERRY: Yes but…in a wheelchair…you were lucky weren't you? (*DANIEL looks away.*) What was it like?

DANIEL: (*Beat, looks at him.*) What do you think it was like?

GERRY: I really can't imagine… I have that film in my head right now…you know that film? That film with that guy…that Die Hard guy?

DANIEL: 'Unbreakable'

GERRY: Yes…yes…

DANIEL: That was the headline they used

GERRY: You're an artist aren't you? Didn't you win some big award straight out of college or something?

DANIEL: (*Beat, quietly.*) The Keating Fellowship

GERRY: Wow…that's big news isn't it? That's like…like…like a Turner Prize.

DANIEL: It recognises an above average achievement for a post graduate show

GERRY: It's a big deal though isn't it? A big award?

DANIEL: I guess

GERRY: What was it like getting it? Getting an award? Did you have to make a speech? I've always wanted to have the opportunity to make a speech. What did you say? In yours?

DANIEL: I mainly spoke about the show, the paintings

GERRY: Yes?

DANIEL: They were abstract portraits of homeless people

GERRY: Really? (*Beat.*)

DANIEL: I paid them, I didn't exploit them or anything, I represented them (*Anxious to get back to why he is here.*) My dreams...they're about the crash...but I don't really remember the crash... I blanked out...completely...it's all just darkness from the minute it happened until I woke up in the ambulance...but in the dream... I remember it all...everything (*Beat.*) Every piece of glass breaking and everyone screaming and...every bone breaking and people being...ripped...burned...screaming. And it's in here (*Indicates his head.*) lodged in here and I'm fucking terrified...because I don't know that I'll make it... I think I might die with the rest of them...my chances are the same as everyone else's...

GERRY: I was in an accident once, I was on my bike and a woman who was parked up ahead just opened her door without checking and knocked me right off, I got quite a shock

DANIEL: (*Beat.*) Okay (*Beat.*) Everytime I have one of these dreams and I wake... I have this feeling...like part of me hasn't woken up yet...part of me is still there...hearing and seeing all those things and not knowing if I'm going to live or be crushed or burnt to death...this feeling...is devastating me...it's affecting everything...like I've lost something. I'm grasping all the time...just to get by...just to eat sleep talk to people... I can't talk to people

anymore…clutching at things just to try and hang on…and I feel…sad…alone…all the time…sad…incredibly sad… and guilty…that they're all dead and I'm not…and in the dream there's a voice…and it calls me and I'm trying to find it because I know if I find it then I'll be okay…that I'll make it…so part of me hates the dream and part of me needs it (*He looks at GERRY expectantly.*)

GERRY: (*He stands up and sits, stand up and sits, he does not know what to do.*) I… I don't think I can help you. Sorry. Do take care (*He moves towards the window.*)

DANIEL: But I paid you

GERRY: For a consultation and my professional opinion is that I can't help you

DANIEL: But (*Beat.*) but I can't work… I have this exhibition… and it's the Keating exhibition…it's…it's where everything is supposed to take off from…it's the beginning of my career…

GERRY: (*Picking up his binoculars and looking out the window.*) I can refer you to a colleague of mine who can help you

DANIEL: But I want you to help me

GERRY: But I can't

DANIEL: You helped David Wrixon. He was an artist, he was blocked, you made him better

GERRY: He had a very particular type of schizophrenia

DANIEL: I know that I know all about what you did for him, I wrote my thesis on him. One of his pieces just sold for over four million

GERRY: I'm sure that's a great comfort to him now that he's dead. (*Beat, DANIEL doesn't say anything.*) David was a patient of mine and a very troubled young man. His suicide was a tremendous blow to all of us (*Beat.*) I'm not taking on clients I'm writing a book…a sequel

actually…to my very successful first book…it's a thriller…a psychological thriller…obviously… (*Looks up at him.*) My last one was called *Through the Forest* (*Looks at him waiting for a reaction.*) It was a best seller

DANIEL: When?

GERRY: 1991

DANIEL: I was ten in 1991

GERRY: Well… I've had a lot of clients…been very busy. I'm not taking on any more right now so you'll have to…you know…go

DANIEL: I think I'm going crazy

GERRY: You're not going crazy

DANIEL: How do you know?

GERRY: I'm a psychiatrist, I would know if you were crazy

DANIEL: I am I am I am (*He hits himself in the head.*)

GERRY: Stop that… (*He does it again.*) That's not crazy that's just stupid

DANIEL: (*Beat.*) Okay I'm not crazy now but I may become… crazy… I'm having crazy thoughts… I'm walking over a bridge and I want to hurl myself off… I'm chopping vegetables and I want to cut my fingers off…that's crazy

GERRY: (*Beat, looks away.*) I know how you feel (*Beat.*) I've been through some tremendous pain recently and I can empathise with how you feel (*Beat.*) but I can't make it better

DANIEL: Please? (*GERRY walks to the window.*) Please?

GERRY looks out. DANIEL hits his head off the desk suddenly, the blow is strong enough to make him fall to the floor. GERRY moves to him quickly.

GERRY: What…what did you do that for?

DANIEL: I don't know. (*Beat.*) I thought it might make me feel better. (*Beat.*) I just want to feel better...can't you help me? Please?

Lights down.

SCENE FIVE

DANIEL's apartment. Night time. STEPH enters, giggling, she is drunk. KARL follows her, he's in his late twenties, wearing glasses and a leather jacket. There is something attractive about him that isn't immediately obvious but he has a chip on his shoulder and is insecure, this manifests itself in feigned arrogance.

KARL: (*Walks in, looks around.*) Bit of a fucking dump eh?

STEPH: Shh...it's alright

KARL: Fuck sake...can't even see where I'm going...

STEPH: I'm over here

KARL: Where?

STEPH: (*Lighting a lighter.*) Over here

KARL: I see you (*Looks at her hard.*) Come here

STEPH: (*Giggles.*) What for?

KARL: 'Cos I said so

STEPH: (*Giggles.*) Alright

> *STEPH moves towards him, he lunges for her, trips over a pile of clothes and falls behind the couch. She giggles.*

KARL: Shut your face (*Standing, STEPH still giggles.*) What are you laughing at?

STEPH: You fell

KARL: So?

STEPH: So it was funny (*Awkward beat.*) Sorry...sorry...sorry

KARL: Could have hurt myself, could have broken my neck

STEPH: Don't say that (*STEPH goes to touch his neck and he pushes her away.*) Sorry

KARL: (*Beat.*) Anything to drink?

STEPH: Lots…lots to drink

> *STEPH goes to the kitchen, KARL looks about, picks up some of the canvases and looks at them, then tosses them aside casually. STEPH re-enters with two cans of beer.*

KARL: So you live here?

STEPH: For the moment…it's my brother's place… I told you. (*Beat.*) I told you I'm just up here remember?

KARL: Huh?

STEPH: I've just arrived…remember? I told you in the club, I'm from –

KARL: Oh yeah (*Takes a can of beer.*) So when did you see me?

STEPH: In the club

KARL: Yeah?

STEPH: Yeah in the club

KARL: But when?

STEPH: When I saw you (*She giggles.*) that's when I saw you…

KARL: What did you think when you saw me?

STEPH: I thought… I dunno… I'm not very good at this…

KARL: It's simple…what did you think when you saw me?

STEPH: (*Coming back into the room.*) I thought… (*Stops for a second, closes her eyes, deep breath.*) I thought 'fuck me is he looking over here?' (*Looks at him, smiles.*) and you were (*Beat.*) Why? What did you think of me? When you saw me? First? What do you remember?

KARL: I remember how you were dancing that's what I remember

STEPH giggles, she sits on the couch, he sits with her, opens the can, drinks half.

STEPH: So what is it you do?

KARL: I'm in production

STEPH: (*Impressed.*) Wow…what kind of production?

KARL: TV…film…music videos…that kind of thing

STEPH: (*Eyes wide.*) Wow…anything I might have seen?

KARL: I don't know do I? Don't know what you've seen

STEPH: No but…you know anything big?

KARL: Big…it's…you can't like say…like put things into…into boxes…you know?

STEPH: Sure…sure… I love music videos… I love watching the dancers… (*Beat.*) From Danny's room you can see right across the street into the national ballet company's studio…sometimes I just go in there with my dinner and watch them…there's one girl…she must be like the top ballet dancer…she always has the solo dances…and sometimes when I'm watching her I want to cry…isn't that crazy? (*KARL is getting uncomfortable.*) Like a proper cry, like she reminds me of something that I miss…and when she's dancing she looks…weightless… I'd love to be weightless…you know? I always wanted to be a singer… when I was younger…used to take my mum's hairbrush and stand on the bed…pretend I was Madonna (*KARL looks at her, she's embarrassed.*) Just make believe…just dreaming like (*Beat.*) You have any dreams?

KARL: No

STEPH: Everyone has dreams, or goals, or…you know… ambition.

KARL: No

STEPH: Oh go on you must have one

KARL: (*Something strikes him, but he's not sure if she's genuine.*) You serious?

STEPH: Yeah

KARL: (*Vulnerable and earnest but still guarded.*) Well it's not...not a dream or anything...but I've had this idea...

STEPH: Go on...

KARL: For when you're in your car...and you know...it's hot...and you're driving about from one place to the next and you reach down for your coke and it's warm

STEPH: I hate warm coke

KARL: Exactly, so my idea is a little gadget, just the size of a coke bottle or a water bottle...that you fit your bottle into and it keeps it cold...so when you reach down for your coke...it's cold

STEPH: (*Beat, she stares at him.*) I think that's brilliant

KARL: You do?

STEPH: Of course I do, that's like...genius...why hasn't someone already come up with that? I mean think of all the hundreds...thousands...millions of people that you will be helping. You should go to those places where inventors go and get it copy written and then you'll make millions...

KARL: I don't know

STEPH: Millions Karl...that's just...brilliant... (*She kisses him then sits back embarrassed.*)

KARL: (*Looks at her.*) You have the look of a pop star you know

STEPH: (*Delighted but embarrassed.*) No...

KARL: You do…lovely eyes…nice body…maybe I could make a few calls

STEPH: You haven't even heard me sing

KARL: Yeah but you know…when you know, right? When you're in the business…you know who has it and who doesn't…

STEPH: You think I have it?

KARL: Fucking too right (*He lunges for her, they kiss madly, she comes up for air.*)

STEPH: You really think I have it?

KARL: (*Kissing her neck, undoing her blouse, muffled.*) Absofuckinglutely

STEPH: How do you know?

KARL: (*Stops kissing her.*) Just do

STEPH: Yeah but how?

KARL: (*Beat, thinking.*) Because you know…you're special

STEPH: (*Almost in tears.*) You think I'm special?

KARL: Just said it didn't I? Don't go around just saying stuff

STEPH: Special

KARL: Beautiful…special…

He lunges for her again. They kiss madly but KARL is definitely the one in control. In a quick movement he gets on top of her and he pushes her down on the couch. He pulls up her skirt and undoes his fly. They have sex quickly and manically, her just holding on to him while he is lost in what he is doing. He finishes and sits back up. STEPH sits up and pulls her skirt down. She is somewhere between horrified and delighted. She reaches out and touches his face, he moves away, reaches for his beer. DANIEL enters covered in paint.

DANIEL: Steph?

STEPH: (*She stands, KARL does up his pants.*) Danny…shit…
sorry… I was trying to be quiet…sorry…sorry

DANIEL: Are you okay?

STEPH: Yeah…yeah I'm… I'm fine I just… I brought
someone… I mean I met someone… (*She moves to the
couch.*) I hope you don't mind but…this…this is Karl

DANIEL: Hi

KARL: Alright

STEPH: We were just…we were having a beer…you want one?

DANIEL: I heard a noise, I thought there was something wrong

STEPH: No…nothing wrong…you want a beer?

DANIEL: If I'm not disturbing –

STEPH: No God no…no…

 *STEPH exits, DANIEL turns on the light and sits in the armchair
 beside KARL, DANIEL is a bit distracted, it's awkward.*

KARL: Daniel is it?

DANIEL: Yeah

KARL: (*Beat.*) Right (*Beat.*) This your place?

DANIEL: Yeah

KARL: What's with all the paint and shit?

DANIEL: (*Beat.*) I paint (*Long awkward beat before STEPH enters
 with a bottle of whiskey and three glasses.*)

STEPH: So… (*Carries bottle over to table and pours.*) Karl is into
 production

DANIEL: What kind?

KARL: You know…bit of this…bit of that

STEPH: He says I should give the singing a go…said he'd make a few calls

KARL: I know you…you're that guy…that guy from the bus crash… I never forget a face…fuck me…fucking hell man…unbreakable or what?

STEPH: Everyone says that

KARL: So? What was it like?

DANIEL: (*Drinking back the whiskey and pouring himself another. Over the course of this scene he drinks a lot of whiskey.*) I don't really like talking about it

STEPH: He doesn't

KARL: Did you see all the bodies? Did you have to walk over them to get out?

DANIEL: Don't really remember

STEPH: He doesn't

KARL: On the news they said it took one girl's head right off…said a sheet of metal ripped it right off…did you see that? They showed a picture of her, young girl, red hair. Did you see her head?

DANIEL: No… I don't remember

KARL: What? You don't remember anything?

DANIEL: No

KARL: Why? You like…brain damaged or something?

DANIEL: No… I just… I blacked out…

KARL: (*Beat.*) Saw a documentary about a guy who almost died once…got lost at sea and blacked out…said he even saw the light at the end of the tunnel…angels in white dresses and everything…but then he got saved by these Japanese fishermen looking for whales or something. He said everything tasted fucking amazing after that…even a

piece of cheese tasted like...like...fucking amazing...you get that? With cheese?

DANIEL: No

STEPH: Daniel's a really good artist...he won this huge award

KARL: Oh yeah?

STEPH: Where were you today Danny? I waited for ages, thought we could go out.

DANNY: I went to see a Psychiatrist

STEPH: Did you?

DANIEL nods, KARL picks up the painting of the ship.

KARL: This one of yours?

STEPH: Why did you go to a Psychiatrist Danny?

KARL: What is it?

DANIEL: It's for the show

KARL: (*Turns it upside down.*) Seriously what is it?

DANIEL: You don't see anything?

STEPH: Danny?

KARL: Do you see something?

DANIEL looks at it.

DANIEL: (*Beat.*) I don't know

STEPH: Danny?

KARL: Can't see a fucking thing

STEPH: (*Frustrated with KARL.*) It's a ship

KARL: Where?

STEPH: There's the stern

KARL: I can't see any ship, where is it?

DANIEL: (*In a daze.*) I don't know

KARL: (*Takes the canvas and holds it in front of DANIEL's face.*)
Show me (*STEPH goes to show him.*)

STEPH: It's – (*KARL pushes her back.*)

DANIEL: (*He lifts up his hands to the canvas, he runs his fingers
along the surface and traces the ship as he sees it, but his hands
begins to move more erratically.*) I don't know

KARL: Why'd you say it was a ship then? If it's not? I mean is
it the kind of ship only you can see is it? (*Beat.*) This is your
contribution? To life? A fucking ship that no one can see?

STEPH: I don't think I have a contribution...do I Danny?

KARL: I fix things...something is broken...like your telly...
your satellite dish...means you can't watch your shows...
see the news...watch a film... I fix it...electronically... I
make it so you can...that's a contribution

STEPH: Thought you were in production?

KARL: I work... I actually...sweat...when I work... I help
people...when people look at what I do...they know what
it is...know what it's for...you know? It was broken, I fix it,
you know?

DANIEL nods.

STEPH: Thought you were in production Karl?

KARL: (*Frustrated at her interruption.*) I... I... I fucking...
moonlight between the two...alright?

STEPH: Oh...why did you go to a Psychiatrist Danny? Are you
sad? (*He is staring at the canvas.*)

KARL: This what you won your award for? This kind of stuff?
(*DANIEL nods.*)

STEPH: I think it's pretty… I like the colours, reminds me of swimming in the lake…remember the lake Danny? You used to take me there all the time

KARL: But what's it for?

DANIEL: People like it…like looking at it…it makes people feel things when they look at it…makes them happy or sad or whatever…people just like it

KARL: Like the way people like watching TV?

DANIEL: Yeah

KARL: Only fucking useless

DANIEL: (*Beat, he's wearing him down, STEPH hugs him.*) It's not useless

KARL: (*Beat, sees he's affecting him, enjoying it.*) Almost died… lucky weren't you?

DANIEL: Lucky

KARL: Want to have –

STEPH: Leave him alone Karl

KARL: Want to have something to say that means something?

DANIEL: I have something to say

KARL: What?

DANIEL: Lots of things about…lots of things…about…

KARL: (*Holds out his hand.*) Here (*DANIEL looks at him.*) Give it here

STEPH looks concerned, she tries to protect the painting. DANIEL hesitates then gives it to KARL.

STEPH: Don't…don't hurt it…

KARL: I'll show you a ship (*He takes a marker from the table and draws a crude and childish shape of a boat.*)

STEPH: Don't (*DANIEL watches on in a daze.*) Danny don't let him…

KARL: There's a fucking ship for you… (*He drinks.*) I can see that…can you?

DANIEL: (*Takes the canvas.*) I can… I can see it…

The bulb flickers and goes out.

STEPH: Shit… Danny? You have another bulb? (*DANIEL doesn't answer.*) Danny?

Lights down.

SCENE SIX

The park. LJ sits watching DANIEL staring at something off-stage, he is more fragile than before.

LJ: She's going to think you're a fucking freak if you don't stop staring at her

DANIEL: I'm not staring

LJ: Well what exactly are you doing then?

DANIEL moves away.

DANIEL: I just… I feel like I should say something

LJ: Fine then, go on, say something

DANIEL: (*Beat.*) I don't know what to say

LJ: You know all you are to her is a reminder that her daughter didn't make it, that her precious baby was decapitated and here you are walking about in the full of your health (*Beat.*) Look, I know you're worried about the exhibition but you just have to do your best, that's all you can do, just do your best

DANIEL: Do my best?

LJ: Well what do they expect? After what you've been through, I mean if you're a bit behind schedule then they should accept that

DANIEL: I'm not a bit behind schedule LJ

LJ: I thought that's what all this was about

DANIEL: I haven't even started

LJ: But...you've been locked up in your studio for weeks...

DANIEL: Yes

LJ: Yes? What the fuck have you been doing in there?

DANIEL: Reading mostly, reorganising the furniture, I painted one of the walls completely black then white then black again.

LJ: Well where do you usually get your ideas from?

DANIEL: They're just there, sometimes they're not...now they're not

LJ: (*Wants to help.*) We had this writing teacher once and she said if you can't think of anything to write about you should go through a newspaper and look at the headlines because real people are more fucked up than anyone you could make up... (*Beat.*) She didn't actually say fucked up but...you know...she was a nun I think. I went through papers that time and found this article about the Empire State Building that said that somewhere at the bottom there's a sign that says don't look up...because if you look up you'll fall backwards...but how could you expect someone to stand at the bottom of the Empire State Building and not look up? When I read that I thought... that would be a good thing...to write a story about...but I didn't know where to start. (*Beat.*) But you could try that, looking in the paper, for ideas. (*He's not listening, looking off stage.*)

DANIEL: (*He reacts to something off-stage.*) She's leaving…same time every day…she comes here with a coffee…sits on that bench…drinks and stares out over the water…stands and leaves…same time every day… I bet she's thinking about her daughter…

LJ: How do you know?

DANIEL: What?

LJ: How do you know if she comes here every day? (*Beat.*) You following her? (*He doesn't answer.*) She's not even pretty

DANIEL: What's that got to do with it?

LJ: You're beginning to piss me off you know that? You hardly ever call – (*Stops herself.*) you need to fucking move on Daniel, you need to get on with your fucking life and let me get on with mine and stop obsessing over it all. You need to move on.

DANIEL: I can't

LJ: Why not?

DANIEL: (*Beat.*) What if I was standing two inches to the left of where I was? What if I had decided to sit down or if I had gone to the upper deck? What if I dropped my wallet or my phone in that instant before the truck hit? I'd be dead now right? Like the rest of them.

LJ: But you're not

DANIEL: But I could be, there was just this much (*He gestures with his fingers just a tiny fraction.*) between life and death, this was the difference between me standing here now or being buried somewhere six foot under.

LJ: So fucking what? It is what it is, what's the point in talking about what might have been?

DANIEL: Because I have to know if it means something.

LJ: Of course it means something

DANIEL: What? What does it mean? (*She can't answer.*) I have to make it mean something... I have to... (*Beat.*) What would you have wanted, if you had died?

LJ: Would it matter what I wanted? I'd be dead.

DANIEL: Think about it, if it had been you and someone else had survived and you were looking down on them, what would you want them to do?

LJ: I wouldn't want them to do anything, I would want them to get on with their lives

DANIEL: I wouldn't...

LJ: Well what then?

DANIEL: I don't know, but I wouldn't want them to forget me, to forget how lucky they were, I would want them to remember me

LJ: Danny, we didn't even know these people, how are we supposed to remember them?

DANIEL: (*Beat.*) I don't know yet...but I'll think of something... I'll think of something...

Lights down.

SCENE SEVEN

Art Gallery, GERRY stands looking at pictures on the wall. He looks slightly uncomfortable in the surroundings but is genuinely intrigued by the exhibition. The pictures are hard to make out at first, but as the scene goes on they become clearer. They are all of dead bodies, in various states of mutilation/decay. LJ wheels in after a minute. She has made an effort, wearing an expensive top with sparkly jewellery and too much make up. She still doesn't look like she belongs there. He realises she is watching him.

GERRY: Fascinating (*Beat.*) Isn't it?

LJ: Well it's dead people

GERRY: Sorry?

LJ: Dead people…people always want to look at dead people…makes them feel alive

GERRY: Yes

They both look at it.

LJ: You probably saw me in the paper (*Looks at him.*) You think I'm lucky

GERRY: Well…not for me to say I guess

LJ: People I don't even fucking know tell me…

GERRY: Well it's subjective isn't it? (*LJ looks at him.*) You mightn't feel very lucky

LJ: (*Looks back at the picture.*) Bet she thinks I'm lucky and all. (*Beat, she looks at him.*) I'd rather have my legs back… (*He nods.*) but then you know I saw this girl on the telly once who was born without any arms or legs…she's just a lump…so…least I know what they felt like…legs

GERRY doesn't know what to say, LJ moves on to the next one, GERRY follows her.

I was sitting beside her before it happened

GERRY: (*Shocked.*) Really?

LJ: She was staring at me…that look…that… 'I don't know where you've been don't touch me' look… (*Beat.*) …was on the tip of my tongue to ask her what she was looking at…tell her it was an invasion of my privacy to be staring at me like that (*Beat.*) Guess the tables are twisted

GERRY: Turned

LJ: Whatever…

GERRY: She looks a bit like my wife

LJ: Really?

GERRY: Yes

LJ: You better not tell her she looks like a dead girl

GERRY: Better not

LJ: (*She looks at him.*) I'm LJ

GERRY: Gerry (*They shake hands.*)

LJ: So what you think of the show?

GERRY: I think he's very brave…

LJ: Yeah?

GERRY: It forces us to look at what happened with an assertive and compelling sense of mortality. By using the corpses as materials, he has transcended the traditional relationship between the living and the deceased. Don't you think? (*LJ doesn't know what to say.*) I actually think I might be a little bit jealous of him

LJ: Why?

GERRY: Lots of reasons…youth…originality

LJ: You're not that old

GERRY: Things seem different when you're young…you're fearless…you think that if you fall you can always get back up again… I don't know when or what exactly happens but that just goes…and the idea of falling is so bloody terrifying that you can't bring yourself to try

LJ: Fucking hell

GERRY: Sorry

LJ: You're not that fucking old

GERRY: Maybe I feel very old

LJ: You an artist?

GERRY: No…God no… I'm a psychiatrist

LJ: Really?

GERRY: Really

LJ: They told me I should talk to a shrink but I wasn't having any of it. Wouldn't know what to say

GERRY: Most people think that at first

LJ: And then?

GERRY: And then you can't shut them up. (*Beat.*) But that's an important part of it, just talking, part of how you help them. (*Beat, quietly, almost to himself.*) I'm actually being investigated right now so I might not be in a position to listen to anyone ever again

LJ: What for?

GERRY: Someone was in pain and I helped them

LJ: What's wrong with that?

GERRY: (*Beat.*) I helped them to die

LJ: (*Beat.*) You killed someone?

GERRY: No, I helped them

LJ: What did you do? Shoot them?

GERRY: (*Laughs quickly, stops when he realises she is serious.*) No

LJ: How then?

GERRY: (*Very serious.*) Drugs. Just drugs.

LJ: Jesus. (*Beat.*) What was wrong with them?

GERRY: They were ill...not physically ill

LJ: What? They were mental?

GERRY: No, they just...were in pain...psychological pain

LJ: Jesus Christ, what you telling me for?

GERRY: I –

Enter DANIEL, wearing jeans and a casual t shirt, hasn't even made an effort. Surprised to see GERRY.

DANIEL: There you are

LJ: What you mean 'there I am'? I've been hovering around you all night, couldn't get past all the fans

DANIEL: I… I didn't see you

LJ: Well I've been talking to Gerry, he's feeling…old, Gerry this is Danny

GERRY: (*Goes to say they've met but DANIEL cuts him off.*) Yes we've already –

DANIEL: (*Holding out his hand to shake GERRY's.*) Gerry, hi, nice to meet you

GERRY: (*Confused.*) Yes nice to…well…well done…on the show

DANIEL: Yes…thanks… (*Anxious to bring his attention back to LJ.*) So what do you think? Do you like the photographs?

LJ: Like?

DANIEL: Well you know… I mean… I hope you weren't…you weren't offended were you?

LJ: 'Course not

DANIEL: I went around to all the families and explained what I wanted to do and why and got each one to tell me about them…who they were…what they did…their plans… future…so everyone would know…so they wouldn't be just another statistic…not everyone agreed obviously…but the rest are all in the book? Did you see the book?

LJ: No. (*Beat.*) What happened to your paintings?

DANIEL: They didn't…mean anything…didn't say…weren't accessible the way this is…everyone can see this… I can see this…you can

LJ: Not blind am I?

DANIEL: (*Beat.*) You don't think…you don't think it's just dead bodies do you? (*Beat.*) Do you?

LJ: What?

DANIEL: Just dead bodies?

LJ: (*Beat.*) Nah…

DANNY: What do you think of it?

LJ: (*DANIEL is still looking at her, she searches for something to say.*) By using the corpses as materials, you have…transcended the traditional relationship between the living and the deceased.

GERRY looks over at her, she avoids his stare.

DANNY: (*Impressed by her response.*) Yeah…yes…exactly…that's it exactly…that's exactly what I was trying to do

STEPH: Well…

DANNY: You're amazing

STEPH: Fuck off

DANNY: I mean it…you are…you're an amazing person. You keep surprising me…

Enter STEPH in a pretty dress, drunk carrying a glass of wine.

STEPH: Danny, they're waiting, they think you should make a speech or something. Everyone thinks you're just… brilliant… (*Delighted.*) I've had my picture taken twice by two different newspapers just because I'm your sister

LJ: (*Wheeling herself out.*) Where'd you get that wine?

STEPH: I'll show you

LJ: Was it free?

They exit leaving DANIEL *alone with* GERRY *who is standing in front of the picture of a young dead woman.*

DANIEL: (*Beat.*) What are you doing here?

GERRY: I was... I was at a funeral actually and I thought... I mean I'd read about it...in the paper...and I thought... I thought I'd come and have a look for myself. (*Beat.*) I thought it sounded interesting

DANIEL: You don't like it, you hate it

GERRY: I don't hate it, why would you think I hated it?

DANIEL: I don't know

GERRY: Why did you pretend you didn't know me?

DANIEL: I asked you for help and you didn't help me

GERRY: Why are you so angry with me?

DANIEL: Because you abandoned me

GERRY: That's not true, I simply wasn't in a position to help you at the time. You see my wife had just died and there were things I had to take care of.

DANIEL: Your wife?

GERRY: She had been ill for quite some time. It was not a shock. (*Beat.*) But I thought of you and I read about this and I wanted to come. I wanted to see you.

DANIEL: Why?

GERRY: Honestly I'm not entirely sure. (*Beat.*) How have you been?

DANIEL: Terrible, different degrees of terrible. You?

GERRY: Similar. Where did all this come from?

DANIEL: I couldn't paint, nothing was coming to me, and then I saw someone and I spoke to her and then it happened.

GERRY: Someone gave you the idea?

DANIEL: Sort of, not exactly (*Beat, he speaks quickly.*) She is the mother of one of the victims, I saw her in the park

GERRY: And you spoke to her?

DANIEL: Not at first but after a while…yes…we spoke about what had happened…about her daughter…about her life and what she was going to become and how she was afraid she was going to forget her. She has a beautiful voice, it's calming, soothing, it seemed familiar to me…and I realised I couldn't take my eyes off her…not because she was beautiful… I mean she is…but she was just so…wholesome. But then she got up to leave…and I panicked… I offered to buy her a cup of coffee but she just looked at me kind of sadly and said she was old enough to be my mother…and I said I knew that (*Beat.*) and then there wasn't anything left to say. (*Beat.*) So I followed her home. She didn't see me and as soon as she went in I left. But the minute she went out of sight it was…just… devastating… (*He looks at GERRY.*) I came home and I lay there thinking about what it meant that I was the only one to be unhurt and what I was going to do and this came to me. (*Beat.*) What do you think it means?

GERRY: What?

DANIEL: All of it, any of it, why was it me?

GERRY: Because it had to be someone

DANIEL: But it wasn't just someone…it was me

GERRY: You are just someone

DANIEL: Not to me I'm not

GERRY: (*Beat.*) You're feeling lost

DANIEL: Yes

GERRY: Alone

DANIEL: Yes

GERRY: (*Going with it.*) Like its pouring rain and everyone else has an umbrella

DANIEL: (*Unsure.*) Y…yes

GERRY: (*Holds out his arms.*) Come here

DANIEL: Why?

GERRY: (*Coming to suddenly, puts his arms down.*) I thought… I just thought that maybe…that maybe I could…

DANIEL: Help me?

GERRY: (*Hard suddenly.*) And what about me? What do I get out of it?

DANIEL: What do you want to get out of it?

GERRY: (*Looks at him.*) I don't know. (*Beat.*) You know I can't even help myself at the moment, can't even, keep things… straight…think straight…

DANIEL: But you could try couldn't you? You came here for some reason and you could just try, what is there to lose in that? Please (*GERRY stares at him, DANIEL takes his hand, GERRY stares at it.*) Please

STEPH enters, she looks at them curiously.

STEPH: Danny, they want you, everybody wants you

DANIEL: Please (*Drops his hand, the crowd continue to chant, DANIEL walks off.*)

STEPH: I've had my picture taken twice tonight

GERRY: How wonderful

STEPH: Isn't it?

STEPH leaves. GERRY stares at the picture. Offstage the chanting gets louder and louder 'Danny, Danny, Danny, Danny'. Blackout.

SCENE EIGHT

GERRY's office. GERRY is sitting at his desk looking at LJ who is seated across from him. They sit in silence for a moment. GERRY is holding the binoculars. He is awkward.

LJ: (*Beat.*) You're probably wondering –

GERRY: Yes

LJ: I didn't finish

GERRY: Sorry

LJ: You're probably wondering why I'm here

GERRY: Oh no… I mean…you're… I'm glad…it's good… you're here… I'm glad…

LJ: You are?

GERRY: It's fine either way…you are here…you're not here… it's fine…

LJ: You ever clean up?

GERRY: Infrequently

LJ: Should get yourself a cleaner, those eastern Europeans work for next to nothing, clean your entire place for a tenner an hour.

GERRY: I'll keep that in mind

LJ: What are those for? (*The binoculars.*)

GERRY: Oh…nothing

LJ: What you have them for then?

GERRY: I (*Beat.*) I (*Beat.*) I like to watch things

LJ: Oh right…get your kicks from watching the neighbours?

GERRY: No (*Beat.*) I watch…the sky

LJ: Birds?

GERRY: No

LJ: Clouds?

GERRY: No

LJ: What then?

GERRY: (*Beat, LJ stares at him.*) Towers. A couple of weeks ago… I was standing at the window…just standing looking out at the water and I saw towers hanging in the air

LJ: In the air?

GERRY: Huge long…like skyscrapers…and they were… glinting in the sunlight…no…not glinting…shimmering… for…for seconds…they were…extraordinary…they were the most beautiful things I've ever seen…and then… nothing…

LJ: Nothing?

GERRY: They disappeared

LJ: Were you drinking?

GERRY: No… I don't drink

LJ: I don't trust people who don't drink, they're too smug about it

GERRY: I'm not smug about it (*Beat.*) You're the first person I've told about this

LJ: Why do you keep telling me things?

GERRY: I don't really know

LJ: Is it because I make you nervous? (*GERRY doesn't answer.*) I find I'm making a lot of people nervous…and they talk…babble…say things they don't mean to…like people feel guilty…just by me being there…makes them feel like they should do something…because to be like this is just about the worst thing they can imagine and no one likes

seeing the worst thing they can imagine…they'd rather put it away…in a box…

GERRY: I've seen worse things

LJ: Like what?

GERRY: You don't want to know

LJ: (*Harsh.*) Yes I fucking do (*Beat, softer.*) I want to know what's worse

GERRY: (*Beat.*) When I was a student…there was a baby born…a little girl…she was so small…tiny…and she seemed perfect at first…but her face…her features hadn't developed…there was nothing there… (*Beat.*) a defect… she couldn't breathe…didn't live for very long…we were brought in to observe and her parents were…distraught… that was…that was probably…probably had the worst effect on me personally…

LJ: (*Beat.*) No face? (*GERRY nods, LJ looks away.*) I wanted to see where he went to, didn't know it was to see you… obviously

GERRY: You followed him?

LJ: What you think you can't follow someone if you're in a wheelchair? You think taxi drivers don't follow whatever they're asked to follow?

GERRY: That's not what I said

LJ: What's wrong with Danny?

GERRY: I can't discuss him with you

LJ: But I'm worried about him. Does he talk about me? (*Beat, GERRY doesn't respond.*) What? You can't tell me that much? Whether he talks about me or not?

GERRY: It's confidential

LJ: You're not planning on…on…doing anything to him are you?

GERRY: How do you mean?

LJ: What you told me in the gallery, about what you did, you're not going to do that...to Danny?

GERRY: No, God no, no...no...

LJ: Good, because there's nothing wrong with him, he'll be fine

GERRY: I know that

LJ: What about the person you...killed?

GERRY: What about them?

LJ: How did you know that they wouldn't be fine?

GERRY: It was my professional diagnosis.

LJ: What does that mean?

GERRY: It means I knew. I just knew. (*Beat.*) Four out of ten psychiatrists believe that doctors should be legally able to help terminally ill patients commit suicide

LJ: Were they terminally ill?

GERRY: No but... (*Beat.*) but it's not so horrible to imagine, when you're in that much pain...

LJ: How much pain?

GERRY: An unbearable amount.

LJ: (*Beat.*) Can I ask you something? (*GERRY nods.*) Do you think I'm pretty?

GERRY: Yes

LJ: Have you ever had sex with a cripple?

GERRY: I don't think that word is –

LJ: Have you?

GERRY: No

LJ: (*Beat.*) You ever have anyone like me? In here?

GERRY: Like you?

LJ: Yeah

GERRY: How like you?

LJ: Like me, been in an accident, left like this, in pain, tired, didn't want to go on? (*Beat.*) Like me

GERRY: (*Beat.*) Sure

LJ: And did you help them? (*GERRY doesn't do anything, beat.*) Did you?

GERRY: (*Beat.*) I tried to.

LJ: You know he's only coming to you because of his father

GERRY: What about his father?

LJ: Didn't he tell you? He killed himself when Danny was eight. I bet that's the only reason he comes to see you, because he misses his dad

GERRY: That's between me and Danny

LJ: Does he know? About you killing people?

GERRY: I don't kill people I –

LJ: Whatever, does he know?

GERRY: (*Beat.*) No

LJ: What do you think he would say if he found out?

GERRY: I don't know

LJ: Why don't you tell me what's wrong with him and that way I won't have to tell him your little secret

GERRY: You know I can't do that

LJ: What's stopping you?

GERRY: You think you're angry with me but you're not, you're angry with your situation and you're angry with Danny

but you are not angry with me. (*Beat.*) Look if you've come here looking for help then

LJ: You think I want your help? Me? Me? There's nothing wrong with me

GERRY: Good

LJ: I'm fine, I'm absolutely A OK in the head department alright?

GERRY: (*Beat.*) Alright

They sit. Lights down.

SCENE NINE

DANIEL's apartment. STEPH is tidying up, humming etc. KARL is watching the TV.

KARL: Stop

STEPH: Stop what?

KARL: Singing

STEPH: I wasn't

KARL: You were

STEPH: I wasn't

KARL: Am I going nuts then am I? Just heard you singing some fucking Britney song didn't I?

STEPH: No you didn't… (*Beat.*) Maybe I was humming, when I'm happy I hum…like now… I'm happy (*He's not listening to her, she stands in front of him.*) I thought you liked my voice

KARL: I can't see the box

STEPH: Don't you like it anymore?

KARL: Told you I like it, just…watching the box…too many noises at once…makes me all…sea sick you know?

STEPH looks confused but nods anyway.

STEPH: (*Beat, trying to be up beat.*) Wow… I can't believe you got me an audition…me…wow…you're brilliant

KARL looks at her, now he's interested.

KARL: I told you I'd look after it

STEPH: (*Beat.*) No one ever looks after me (*Beat.*) What about you? Anyone look after you?

KARL: Don't need anyone do I?

STEPH: (*Affectionate teasing.*) Bet when you were little though… you needed someone…bet you got teased and all…'cos of your specs

KARL: No

STEPH: Bet they called you specky four eyes and goggle head and all

KARL: (*Beat.*) I said no

STEPH: People used to pick on me all the time…call me fatso…miss piggy…thunder thighs…lard arse….jelly bitch…used to stick compasses in me in school…make me bleed…

KARL: (*Horrified.*) What are you telling me this for?

STEPH: Why wouldn't I tell you?

KARL: Because…it's…it's embarrassing isn't it? For you…it's embarrassing for you

STEPH: (*Beat.*) I'm not embarrassed…wasn't my fault…and I like telling you things about me…like you telling me things about you…getting to know each other…it's nice. (*Enter DANIEL from the bedroom, he looks wrecked, he goes to STEPH.*)

DANIEL: Did you take it?

STEPH: What?

DANIEL: I don't mind if you did, I'd just rather you asked is all

STEPH: Take what? (*DANIEL looks at her, then at KARL.*) You alright Danny? (*DANIEL looks back at her.*) Those newspaper guys keep calling, they want to talk about the show, I've had to take the phone off the hook

DANIEL: I need to be able to trust you if you're going to live here

STEPH: You can trust me Danny

DANIEL: What about that time you took my bike and said you didn't?

STEPH: I was only seven

DANIEL: You still lied. Are you lying now? Did you take it?

STEPH: Take what?

DANIEL: I had a picture, of a woman, sitting in the park. I left it here yesterday and now it's gone… I've done the whole place and it's gone

STEPH: What would I want with a picture of some woman? Do I know her or something?

DANIEL: (*To KARL.*) You see it?

KARL: Huh?

DANIEL: My picture, did you see it?

KARL: Didn't see a thing mate… (*DANIEL goes to the coffee table and stand in front of KARL.*) Can't see the box

STEPH: You alright Danny?

DANIEL continues to stare at KARL, then he starts pulling up the cushions on the couch.

KARL: Hey…

STEPH: Danny

KARL: I'm sitting here

DANIEL: (*Quietly at first.*) Move

KARL: Huh?

DANIEL: Move… (*Louder.*) Move. (*Louder.*) Move.

KARL: Alright… (*Standing.*) Jesus Christ… (*Puts on his coat, heads for the door.*) fucking lost it (*DANIEL starts rooting where KARL had been sitting.*) What's up with him?

STEPH: (*Worried.*) He's just looking for something…he'll be okay in a minute…

KARL: I'm going round the pub

STEPH: But I was going to make dinner…you said you liked pasta?

KARL: (*DANIEL is now sitting on the couch with his head in his hands.*) I think it's disgusting what you did…disgusting (*DANIEL looks at the TV.*) You know my mate has a mate whose cousin was on that bus…thought it was fucking disgusting…how you used it…to make money…

STEPH: He didn't

DANIEL: I did

KARL: See? How much money you make?

DANIEL: A lot, but I didn't mean to…

KARL: See?

DANIEL: (*Beat.*) I wanted to do something real…something accessible…something everyone could see

KARL: Should have killed yourself then…had someone take a snapshot

STEPH: Karl (*But DANIEL looks at him, KARL turns and leaves, DANIEL lies down on the couch.*) He shouldn't have…said that…he can be a bit…difficult sometimes but he's a good

guy really…he's going to help me get started you know? And it's all about contacts in this business (*Beat.*) Danny? What's the matter? (*Beat.*) You're not yourself, you want me to call Mum? Maybe she can come out here for a few days, make us some of her dinners? (*She reaches out to stroke DANIEL's hair.*) You know…you know I love you… I love you so much Danny…you're the most important person and thing to me in the whole world…you always have been (*Beat.*) I just couldn't bear it when you left, I couldn't stand it, not seeing you, not knowing what you were up to. (*Beat.*) But I don't know how to look after you (*Beat.*) I can't even look after myself (*Beat.*)

DANIEL: (*Beat.*) You don't need to worry about me

STEPH hugs him tightly.

STEPH: But I am worried. Let's go home Danny, you and me, right now, let's just go home and go down the lake and swim and do all the things we used to do before… (*DANIEL pulls back, STEPH pauses.*) before you left

DANIEL: (*Takes her hands.*) I want you to do something for me, will you?

STEPH: Sure…anything (*DANIEL exits and enters again with a golf club, he hands it to her.*) Golf?

DANIEL: I want you to hit me with it

STEPH: (*Giggles, thinks he's joking, then stops when she sees he's not.*) No

She drops the club, he picks it up again and gives it to her.

DANIEL: You said you would

STEPH: I didn't know you wanted me to hurt you

DANIEL: You won't… I promise

STEPH: Of course I will, it's a golf club for fucks sake

DANIEL: I need you to do this…please…please…

STEPH: (*As KARL re enters.*) I can't

KARL: Can't what?

STEPH: I thought you were gone

KARL: Need some cash, you got twenty I can lend?

> *DANIEL tries to take the club from STEPH, she realizes what he's going to do and holds on to it.*

STEPH: No

KARL: What's going on?

STEPH: Nothing Karl, go away

DANIEL: She won't hit me

KARL: What?

STEPH: No Danny

KARL: (*Indicating the golf club.*) With that?

DANIEL: (*Letting go.*) Yes

STEPH: But I won't do it

KARL: (*He looks at DANIEL.*) You want her to hit you with the golf club?

STEPH: No

DANIEL: Please

KARL: You heard the man (*He wrestles the club from STEPH.*)

STEPH: No, you'll hurt him

KARL: (*Pushing her off.*) He wants to be hurt… I'm just being polite. Now where exactly do you want me to hit you?

DANIEL: Anywhere

KARL: Except the head right?

DANIEL: Huh?

KARL: You don't want me to hit you in the head though…you could die and all that…or the balls…somewhere in the middle alright?

DANIEL: (*Beat.*) Okay

KARL: (*Takes a few practise swings.*) Nice club…you play?

DANIEL: No

KARL: Right then

STEPH: I can't watch… I won't

KARL: Suit yourself

STEPH: Danny

DANIEL: It's okay…really…it's okay… (*To KARL.*) I appreciate you helping me out like this

KARL: That's me alright…just love helping folks out…do it all the time…get a kick out of it, bit of a rush. Yeah that's me…helping people…wherever I (*Swings suddenly and hits DANIEL with the club, knocking him to the floor, STEPH screams and rushes to him, KARL stands back and wipes his forehead.*) …go…

STEPH: (*Sitting on the floor and putting DANIEL's head on her lap.*) You alright? Danny? You want me to call the doctor? (*DANIEL shakes his head.*)

KARL: (*Taking some more practice swings.*) Hey Steph, you got that twenty?

She looks at him angrily then fishes a twenty from her pocket and gives it to him.

STEPH: Just go

KARL: Can I keep this?

STEPH: Just go

KARL: You know he asked for it, was only helping out (*Exits with club.*)

STEPH: (*Sits, stroking his head.*) What you want to do that for?

DANIEL: Feels good

STEPH: How can it feel good?

DANIEL: Feels…just feels…good

Lights down on her holding his head.

SCENE TEN

LJ's apartment, minimalist, expensive. LJ wheels in with shopping bags. She puts the bags down. She opens one of the bags and takes out a new top. With difficulty, she takes off her jumper and tries to put on the new top. We hear someone vacuuming off stage.

LJ: I thought I told you to go (*The vacuuming continues.*) I thought I told you I didn't need you to do that, do you hear me? Do you speak fucking English? I said leave it? (*Vacuuming stops.*) Just get out of here and don't come back alright? Just tell them I want someone else, someone who understands it when I speak to them, who does what they're told, tell them that alright? Tell them fucking that?! (*The doorbell rings.*) And you can get that on your way out (*Beat.*) You understand me? Get the door, the door, the fucking door!

LJ struggles with the top, she is just in her bra now, she is getting more and more frustrated. Enter DANIEL with his arm in a sling.

DANIEL: Oh…sorry… I can wait (*He turns around.*)

LJ: You're early

DANIEL: Wasn't doing anything else so…

LJ: (*Manages to pull the top on.*) Nothing you haven't seen before

DANIEL: Sorry?

LJ: A girl in her bra…nothing you haven't seen before

DANIEL: Oh…yeah…

LJ: Alright…you can look… (*He turns around.*) What happened to you?

DANIEL: Nothing…just…had an accident

LJ: What kind of accident?

DANIEL: It's nothing…really…how are you?

LJ: Alright…you like my place?

DANIEL: It's huge

LJ: Takes me ten minutes to get from the bedroom to the kitchen

DANIEL: It's great

LJ: Want to see it?

DANIEL: What?

LJ: My bedroom

DANIEL: (*Beat.*) I…

LJ: I wasn't sure you'd come

DANIEL: Why wouldn't I come?

LJ: I don't know do I? Just thought you might have…other things to do…now that you're famous

DANIEL: I'm not famous

LJ: (*Snaps.*) Don't be humble it's just fucking annoying

DANIEL: (*Beat.*) It's good to see you

LJ: Why didn't you come around before then? Could have seen me ages ago if you wanted (*Beat, softer.*) Sick of seeing your ugly mug in the paper…every other day…everyone

either loves you or hates you don't they? (*DANIEL looks away.*) Said you got hate mail

DANIEL: Some

LJ: What did it say?

DANIEL: All the same…they want to kill me…take pictures…

LJ: (*Beat.*) So…any groupies then? (*DANIEL smiles shyly.*) Girls dropping their knickers everywhere you go?

DANIEL: No

LJ: Maybe you're not going to the right places (*Awkward silence.*) You want a beer?

DANIEL: No thanks

LJ: You sure? I have a whole cupboard full of booze in there… you might as well have some?

DANIEL: No thanks

LJ: Go on have one

DANIEL: (*Firmly.*) No

LJ: (*Beat.*) Got an interior designer…cost twenty five thousand pounds…all this stuff…you like it?

DANIEL: Yeah I like it

LJ: I can see your building from my bedroom window, just the roof, can see pretty much everything from up here (*DANIEL nods, beat.*) and it's quiet…a bit too quiet sometimes…catch myself feeling lonely have to snap myself out of it…

DANIEL: You could always ask someone to move in with you

LJ: Yeah?

DANIEL: Yeah well I mean, if you're lonely, and it's such a great place, I'd love a place like this, so much light and space…you think you could do that? Live with someone?

LJ: Sure… I mean it would depend on the person

DANIEL: Yeah…

LJ: Would you… I mean…do you…

DANIEL: Absolutely… Steph would love this place…and it's right on the bus route into town…it would be perfect…and she's a girl so…you know…might be weird sharing with some strange guy

LJ: Steph

DANIEL: She's really sweet…and she's not messy all the time and –

LJ: I don't want a flatmate

DANIEL: But –

LJ: I like my own space

DANIEL: Okay (*Beat.*)

LJ: (*She sees a bag.*) I bought something today…in a gallery

DANIEL: Which one?

LJ: The Cube, you know it?

DANIEL: Of course, what did you buy?

LJ: Open it

> *She hands him the bag and he opens it. It is a ugly sculpture of nothing in particular. Could be a piece of junk. DANIEL turns it over in his hands.*

> It's about the exact moment that the Big Bang happened right?

DANIEL: What?

LJ: But that's what the woman said, she said it's a catastrophic gigantic world changing instantly distilled into a piece of

ground breaking art (*DANIEL continues to look at it in shock.*).
Aren't you going to say something?

DANIEL: It's…it's…it's an early piece I made at college… I
don't even know how they got their hands on it…

LJ: What you don't like it?

DANIEL: It's a bit embarrassing actually

LJ: How can you not like it? You made it?

DANIEL: I made it years ago…before I knew what I was doing

LJ: It cost me five thousand pounds

DANIEL: (*Trying to hide his shock.*) Well…

LJ: It's one of a kind she said, it's a collectors item

DANIEL: Look if you like it, that's all that matters

LJ: Fuck sake, just put it down you're annoying me now, put it
down somewhere

DANIEL: Where?

LJ: Give it to me

DANIEL: No just tell me where to (*LJ lunges for it and holds it.*)
Sorry…

LJ: (*Long beat.*) It's been weeks

DANIEL: I'm sorry

LJ: You don't pick up your phone (*Beat.*) I went round your
house the other day. Why didn't you tell me you were
seeing a doctor?

DANIEL: I didn't want to be making things worse for you

LJ: I thought we were friends.

DANIEL: We are

LJ: Then why didn't you tell me? (*Beat.*) You know he's killed people? That's what he does, he's one of those assisted suicide guys, you shouldn't see him anymore Danny, you shouldn't

DANIEL: That's not true

LJ: What you didn't know? He didn't tell you?

DANIEL: (*Beat.*) He's helping me

LJ: You shouldn't see him anymore

DANIEL: I need him to help me

LJ: Help you what?

DANIEL: (*Beat.*) Feel better

LJ: (*Awkward silence, she wheels over to one of the windows.*) I know I'm not like…other people that you know…people you work with…

DANIEL: I…

LJ: No I know that… I know that but… I'm still… I'm a good person… I'm…trustworthy…you can trust me…and you can't say that about a lot of people you know…most people only look out for themselves (*Beat, she looks at him, waits for him to say something, he doesn't know what to say. Change of mood.*) Well I want a fucking drink

DANIEL: I'll get it

LJ: Let's go for a pint

DANIEL: I'm not in the mood for all those people

LJ: I haven't seen you for ages

DANIEL: I know, I'm sorry, It's hard for me to –

LJ: (*Angry she smashes the sculpture on the ground, they both stare at it in shock for a second.*) It's hard for you? It's hard for fucking you?

DANIEL: That's not what I meant

LJ: It's the least you could fucking do isn't it? Bring me for a pint?

DANIEL: What you mean?

LJ: (*Beat.*) We just need some normality that's all, I need to do the things I used to do or else I'm going to take the lift to the top floor and fucking wheel myself off…

DANIEL: (*Standing.*) Right then

LJ: What?

DANIEL: Where you want to go?

LJ: I know a place. (*Beat.*) I'll show you. (*Beat, DANIEL goes to push her chair.*) I can do it… I can do it on my own

Lights down.

SCENE ELEVEN

GERRY's office, he is sitting by the window. He looks at the phone. He walks over to it. Picks it up. Takes a card from his pocket. Dials a number.

GERRY: Hello? Yes…yes is this the (*Reading the card.*) Party Line? Doesn't sound like there's much of a party going on, well there's no music is there? Right, yes that's better, what's your name? George…that's not exactly an Italian name. This is the (*Reading the card.*) Italian Studs Party Line and you…are Italian I suppose? Oh Giorgio…yes I can hear your accent now…very authentic…are there any other Italian studs there tonight or is it just you? It's just you, no, that's okay, that's…fine. My name? My name is…Trevor…yes…you can call me Trev. I'm wearing black shorts…yes they are leather…how clairvoyant of you…short…no not that short…yes…about that length… tanned…oiled…sexy…and…hold on who is calling who here? What about what are you wearing? What about that?

(*DANIEL enters, he hangs up instantly.*) Wrong number, you're early

DANIEL: I'm not, I'm late actually

GERRY: But it's only... (*Checks his watch.*) that can't be right...it was only two thirty a minute ago...imagine that...losing two hours...sit...sit...sit...how are you today?

DANIEL: I'm alright –

GERRY: Actually...why don't we talk about me today?

DANIEL: (*Beat.*) Why?

GERRY: (*Beat.*) Why indeed...why indeed... (*Beat.*) You ever own leather pants? I always imagined leather pants would get very...uncomfortable...

DANIEL: No

GERRY: I imagine they would be very uncomfortable, (*Beat.*) especially in warm weather

DANIEL: (*Explosive.*) What do leather pants have to do with anything?

GERRY: (*Beat.*) You're agitated, I can tell, something happened

DANIEL: I come here and I expect something from you, not much just...your attention...you to listen to me...to hear me... I need you to hear me

GERRY: I'm listening

DANIEL: The girl you met, at the exhibition,

GERRY: LJ

DANIEL: LJ...took me to this place where she used to work, a strip club, in town. I didn't want to go but she makes it difficult for me to say no (*Beat.*) It was horrible, seedy, cheap place, red plastic over the lightbulbs. (*Beat.*) She made us sit right at the front so she could watch the girls dancing. I couldn't even look at her and watching those

girls…dancing…felt like there was battery acid in my stomach and she kept giving me money to give to them and we were drinking…and then…this guy comes over and sits beside us and she recognises him…from when she used to dance…and she says 'Hi Phil' and he looks at her, and he doesn't know her at first and he looks at her chair and then he does know her and…he just says 'LJ?' and she says 'yeah' and then he gives her this look and she says 'It's alright Phil' and he just goes and sits somewhere else. (*Beat.*) And I have to leave her 'cos I'm going to be sick all over the place

GERRY: I hate vomiting in public places, it's vile isn't it? Because you want to put your hand on the toilet bowl but you can't because its disease ridden and you're all like (*He mimes being sick and trying to not touch the toilet bowl.*) It's just not pleasant

DANIEL: When I came out… (*Shakes his head.*) when I came out she was…she's paid this girl…this dancer…to give her a lap dance…and everyone was watching…laughing…and LJ just sat there with this look on her face…like she wasn't even there…she was just staring at this girl and she looked over at me and I just… I couldn't go over there…be part of it… I don't even know what it was but it felt all wrong…felt like I needed a shower…or a hug…or a roast chicken dinner…something fucking…wholesome. I just ran and ended up across the road from her house. Michelle, that's her name, she was in the sitting room at first so I just watched her for a while…watched her watching the telly and I felt…calmed…at ease…fucking…clean. (*Beat.*) And then she got up and turned the light off and moved into the kitchen and it wasn't enough…that much time watching her wasn't enough…so I followed her…she has this lovely garden…flowers…swings…a bench…she washed her dishes and even though she was on her own every now and then she smiled…just to herself…but part of me thought that she was smiling because she knew I was watching…and everything was fine until she finished and

went upstairs… I could see her shadow in the window and even that was alright but then she switched the light off and everything was awful again… (*Beat.*) I didn't break in because she hadn't locked the window in the downstairs bathroom, it was open. The house…it smelled…fucking amazing…like a bakery mixed with a florist…like roses and chocolate cake…amazing. I was just going to stay for a minute…sit on her couch…maybe take a tea towel… I don't know…but the thought of her upstairs. I went to her room and I stood there watching her sleep, watching the way she tucked her hand under the pillow and wore an old t-shirt ripped at the neck, I even thought about waking her up, and telling her, explaining how I felt. And then I saw him, her little boy, he was just standing there in the doorway. I didn't know what to do, I just kind of lost it for a second, I couldn't run for it 'cos he was in the way…and we just kind of looked at each other for a second and…and then I started to cry…

GERRY: You mean he started to cry?

DANIEL: No… I started to cry… I sobbed…huge sobs… shaking…tears rolling down my face and this kid is just staring…and then he walks over to the bed and I'm thinking…this is it…this is where it all ends…my career… my life…this is it…the minute he says the word 'Mummy' I'm completely fucked…but this is it right? He doesn't say it, he doesn't say a fucking thing he just stands in front of her, between me and the bed, like he's protecting her, like he's a fucking German Shepherd and not a six year old boy and I walk to the door and I leave

GERRY: And?

DANIEL: And that's it (*GERRY stares off into space, beat.*) What's happening to me? I don't do things like this, I don't, this is not the kind of person that I am (*Long beat, GERRY is still staring.*) Are you even listening to me? Gerry?

GERRY: Sorry?

DANIEL: Are you even listening to me? I come in here and I vomit all of this stuff out and you sit there and...because if you're not... I mean if you're not listening how can you help me? If you're not even –

GERRY: I'm listening (*Beat.*) I did tell you this would be a slow process, I did tell you I couldn't guarantee that that –

DANIEL: That you would listen to me?

GERRY: I am listening

DANIEL: And what do you think? (*Beat.*) Gerry?

GERRY: You know you kind of look like a young James Dean, anyone ever tell you that before?

DANIEL: I look nothing like James Dean

GERRY: I'm just trying to say –

DANIEL: Well try saying something useful, something fucking relevant...try that...

GERRY: (*Beat.*) You want me to tell you what I think?

DANNY: Why else would I be here?

GERRY: I think you're suffering from post-traumatic stress

DANIEL: Yes

GERRY: And I think you're also experiencing survivor guilt

DANIEL: Yes

GERRY: And I think you have chosen this woman as a tangible link to those who died in the accident

DANIEL: Yes. (*He waits for GERRY to say something else.*) So...so can you prescribe something for me?

GERRY: (*Amused by this.*) It can't be prescribed for. There is no quick fix.

DANIEL: Well how do you usually treat people in my position?

GERRY: I've never met anyone in your position. (*Beat, tired suddenly.*) I think I probably could have helped you once but not anymore, not now (*Beat.*) I have done something I should not have done

DANIEL: Look I know all that, about the assisted suicide (*GERRY looks at him.*) LJ told me

GERRY: It doesn't shock you?

DANIEL: No. Maybe. I don't really know, you probably did what you thought was right

GERRY: I did. Exactly. I wanted to help her

DANIEL: Who?

GERRY: My wife

DANIEL: You killed your –

GERRY: I helped her, I wanted her to stop suffering, I wanted to make the pain go away, I thought it was the right thing but now…the feeling of it…of the guilt…

DANIEL: Is overwhelming…

GERRY: Like you're drowning though you're perfectly dry

DANIEL: Yes

GERRY: Like when sometimes silence is the loudest thing in the world and all you want is to hear a sound to break it

DANIEL: Yes.

GERRY: You and I Daniel, we are similar, we are. You remind me of me, of who I was, of the promise of who I could have been. (*Beat. DANIEL, tired, stands to go.*) Where are you going?

DANIEL: Home

GERRY: You could stay

DANIEL: Why?

GERRY: Because we are both suffering, both alone, both behaving in ways that we should not behave, both on dangerous ground… (*Beat, DANIEL makes a further move to go*.) Because guilt can kill you if you let it, if you want it to (*Beat*.) Do you know what I mean?

DANIEL: (*He turns looks at him, almost whispers*.) Yes… (*He sits*.)

GERRY pours him a drink. They sit.

SCENE TWELVE

DANNY's flat, STEPH is trying on clothes. She pulls on a silver spangly top then takes it off again, then pulls on a pink one to match the pink skirt and pink shoes she's already wearing. She looks at herself in the mirror then strikes a pose.

STEPH: It's so nice to meet you, I'm Stephanie Wilson. It's so nice… I'm charmed…really…yes… I'd like to sing for you today…no…today I'll be singing for you gentlemen that classic iconic track 'What a Feeling'. (*She starts to sing and then the doorbell rings. She panics, pulls a cardigan over her top but she looks ridiculous. She exit, re-enters LJ follows. She is explaining her outfit.*) I was just… I have this meeting coming up…need to look…punchy…you think this is a punchy look?

LJ: I'm not sure what punchy means…

STEPH: Kind of…on the edge…up and coming…Britney in her first video kind of…you know punchy…hit me baby one more time?

LJ: (*Beat*.) So…is Danny here?

STEPH: No he's been out all day, don't know where he is, thought he was with you maybe

LJ: No

STEPH: Oh (*Awkward silence*.) Well I'm sure he'll be back any minute then.

LJ: I brought him somewhere... I think I shocked him...did he tell you?

STEPH: No

LJ: You're lying, he told you

STEPH: He didn't...honest... I'm not a very good liar so you'd know if I was lying

LJ: Right

STEPH: LJ...you know...you can talk to me if you need someone to talk to and you can't talk to Danny. I'm a really good listener, I don't say anything because I don't really know anything about anything so I don't...say anything so...if you wanted to talk to me about anything... you know...you could...

LJ: Why would I want to talk to you?

STEPH: (*Stung.*) Yeah... I know... I mean...why would you? Sure....I understand... I just thought...but sure...sure...

LJ: (*Long beat.*) Sorry

STEPH: No...it's...it's fine

LJ: It's not fine...you were being nice and I was just...cruel. (*Beat.*) I can be cruel sometimes I'm just...not used to... to...

STEPH: It's fine

LJ: It's not fine

STEPH: Really it is

LJ: Really it's not...it's not fucking fine (*STEPH looks at her shocked.*) If you let people treat you like shit then they will always treat you like shit and is that what you really want? To be treated? Like shit? (*STEPH shakes her head no.*) Then... it's not fine, is it? What I said?

STEPH: No

LJ: What?

STEPH: (*Louder.*) No (*Beat.*) Thanks (*Beat.*) You want something to drink? A beer or something?

LJ: What's the something?

STEPH: I'll go and check (*She exits.*)

LJ wheels herself around and moves towards the couch. She is looking at the painting of the ship when KARL enters with a towel around his waist. He looks at LJ.

STEPH O/S: We've got vodka or rum and some coke to mix?

LJ: Vodka

STEPH O/S: Coke?

LJ: Straight is fine

KARL: Alright? (*LJ stares at him. STEPH enters from the kitchen with a glass of vodka, they both look at her.*)

STEPH: Here we are, oh, this is Karl, Karl this is LJ she's a friend of Danny's

KARL: Alright

LJ: Yeah

KARL: You an artist as well?

LJ: No…

KARL: That's one of my best works you have there…what do you think? Picasso or what?

STEPH: (*Handing her the vodka.*) Don't mind him, it's one of Danny's but Karl ruined it

KARL: Improved it so I did…wasn't anything before was it?

KARL starts drying himself.

LJ: (*Sips her vodka.*) What time did he leave? Danny?

STEPH: This morning…early…he's been out a lot actually… these days…guess he's working on his show…hope he is…people ringing here all the time…he hasn't told them what venue or what it's going to be or anything…hasn't even given them a brief

LJ: What's a brief?

STEPH: I don't kn –

KARL: You like what he did? With those bodies?

LJ: (*Beat.*) Yeah

KARL: Why?

LJ: I don't know

KARL: Bollox

STEPH: (*Trying to distract him.*) So what you think of my outfit? (*Taking off her shirt.*) You think it's punchy?

KARL: (*Getting dressed.*) Skirt is too long

STEPH: What?

KARL: Too long…not enough leg…need to show a bit of thigh to these guys…

STEPH: I can take it up I guess…not too much though… I don't want them to think I'm that kind of girl

KARL: That's exactly what you want them to think, sex sells Steph

STEPH: (*To LJ.*) What you think LJ? You think I'm showing enough l… (*Realises what she's saying.*) leg? (*LJ looks down, STEPH looks at LJ's non existent legs.*) I mean…it doesn't matter does it… I mean it's my singing that counts…that's what sells records

KARL: You look familiar to me, have we met before?

LJ: No

KARL: Maybe we bumped in to each other somewhere, on a night out or something

LJ: No

KARL: How come you're so sure?

LJ: I'm good with faces (*Beat.*) I'd remember you

KARL: Yeah… (*Looks at her.*) I know…maybe you came down my dad's garage…he has a small tyre place on the North side… Digger's…maybe you came down there one time had a tyre fixed

LJ: No

KARL: Just as well…he's an asshole…never did an honest job on a tyre that I saw…people coming in…not much money 'cos that was the type came around ours…and he'd take money off them for a new tyre and just patch it up…so they're back in a few weeks later…and again…'till they figure it out…that is not a contribution to life that is a burden (*Beat, lighting a cigarette.*) Parents are a fucking burden…if you could chose them…then maybe they wouldn't fuck you up

STEPH: (*Concerned.*) Oh my God, your parents fucked you up?

KARL: He was an asshole…never one kind word for my mother and she was a saint…a fucking saint she was. You ever need a tyre fixed…don't go there…

STEPH: (*Nodding sympathetically.*) Okay…though… I don't have a car so…

KARL: (*He drinks from a can of beer on the table.*) You look familiar though

STEPH: (*Trying to take the attention back to herself.*) You know I think this is better than the silver top because there's more unity in the top and the skirt matching don't you think? I mean they say if you want to look slim you should wear the same colour up and down? (*KARL and LJ are staring at*

each other.) Hey LJ you want to hear my audition piece? I could use the practise… (*Beat, desperately.*) LJ?

LJ: (*Looks at her, beat.*) Sure

STEPH: (*Delighted.*) Really…great…thanks…well I'll just…just pretend… (*Grabs the remote control.*) that this…this is the microphone…and the crowd…the crowd is out there and they're all cheering…really cheering… (*KARL turns his back to us and drops his towel and pulls on his jeans, LJ watches him, STEPH tries to take the attention again.*) And I'll come in from back stage and my hairs all done and my make up and I look… I look… I look punchy you know? And then I start

She starts to sing, hesitantly at first but slowly she gets lost in it, as if she forgets the other two are there and singing to an imaginary audience. She is not bad, but not great, she will not become a star. As she sings, KARL gets dressed in a way which seems overtly sexual, like to watch him would be wrong and he is very aware that LJ is watching him, every button tied is an invitation, they lock eyes from time to time, LJ cannot look away. STEPH finishes the chorus and stops. She breaks the spell between the other two and LJ looks away embarrassed. STEPH looks at them both, desperate for them to say something kind. They say nothing.

So…what you think?

LJ: Huh?

STEPH: What you think? Of the song?

LJ: Good

STEPH: (*Delighted.*) Really?

LJ: Sure…

STEPH: Thanks… Karl?

KARL: Needs more practice

STEPH: Yeah… I can see that…yeah… I'll do some more work on it…you know…later… (*She sits dejected on the couch, takes off her heels.*) I can see that… (*Beat.*) I can…need to do a

proper warm up first…loosen my vocal chords…shouldn't just be going straight into it

KARL puts his coat on.

KARL: I'm away

STEPH: What?

KARL: Have a meeting, I told you

STEPH: Oh about the…oh…great…well great…good luck…

KARL: (*To LJ.*) Was nice meeting you

STEPH leans in for a kiss but he exits without giving it. As he does DANIEL enters, KARL doesn't acknowledge him.

STEPH: See I told you he'd be here in a minute, look Danny LJ's come to see you

LJ: Hey

DANIEL: (*He focuses on LJ, registers guilt.*) Hey

LJ: Something wrong with your phone? I've been trying it all weekend

DANIEL: I've been busy

LJ: Apparently… (*Beat, desperate.*) Look I'm sorry I brought you to the club. I'm sorry but I just needed… I guess you think it's weird that that would be anybody's normality but it was mine. (*Beat.*) I'm sorry if I…if it shocked you

DANIEL: It's okay

LJ: But at the same time I don't know why it should shock you, most guys, most guys wouldn't have found it so bad to be sitting in there watching the girls dance, it wouldn't have been so…so shocking.

DANIEL: It wasn't the girls

LJ: Oh…good then.

STEPH: (*Standing.*) I'm going to…you know…start dinner so…

DANIEL: Stay (*STEPH looks uncertain.*) Stay (*STEPH sits.*)

LJ: Why did you run out like that?

DANIEL: I couldn't be there with you

LJ: What was wrong with being there with me?

STEPH: Yeah Danny?

DANIEL: (*Beat.*) Everything…sitting there beside you watching them…dance…and that man…and the way he looked at you…like…like…

LJ: Go on

DANIEL: Like you were…a freak (*He doesn't know what to say the unspoken word just hangs there, very uncomfortable. STEPH stands to go.*) Sit

STEPH sits, she looks at each of them while they talk, stuck in the middle.

LJ: (*Beat.*) I didn't ask you to… I never fucking asked you to…to…to feel things for me…to feel sorry for me…to pity me…my feelings and my…my fucking feelings are none of your business do you hear me? Do you?

DANIEL: I'm sorry… I just wanted… I'm doing the best I can but it's…

LJ: Then do fucking better Daniel. Is that all I am to you? Someone that you can pick up and drop whenever it suits you? Someone you feel sorry for?

DANIEL: No but I –

LJ: I'm only in this fucking chair because of you. (*She stops, STEPH and DANIEL look at her.*)

DANIEL: What do you mean?

LJ: (*She softens, she can't look at him.*) I saw you that day…on the bus…before it happened… I was supposed to get off two stops before but I was watching you. I remember you were smiling…looking at people…taking them in. I didn't want to leave until you had taken me in…smiled at me…and at each stop I worried that you would get off. I didn't want you to get off that bus and I didn't want to get off myself and now look at us. (*Beat.*) Neither of us did. And you didn't look at me until after, until I looked like this.

DANIEL stares at her, he can't believe it, he backs away shaking his head and exits. STEPH stares at a crumbling LJ.

STEPH: He'll be back in a minute, honest, he didn't –

LJ: Shut up Steph

STEPH: (*Looks at her, shocked, indignant, beat, thinks.*) You shut up (*LJ looks at her.*) I said it, shut up yourself (*Beat, falters.*) Sorry

Lights down on the two sitting in silence.

SCENE THIRTEEN

Wasteland, bus debris, GERRY sits in the middle of it. His behaviour is erratic. DANIEL walks around, he has the camcorder and is videoing what he sees. They pass a bottle of rum back and forth to each other. Both are tipsy and becoming more drunk as the scene goes on.

GERRY: It's a bit…depressing here isn't it?

DANIEL: I don't think so

GERRY: Like a graveyard

DANIEL: It's peaceful… I can think here…it relaxes me

GERRY: And they let you come and go?

DANIEL: It's for my work

GERRY: Ah… (*Beat.*) That what that is for? (*The camcorder.*)

DANIEL: It records the intensity of the moment

GERRY: (*Beat, thinks about this.*) How do you know which one's are worth recording?

DANIEL: (*Beat.*) You don't

GERRY: Thank you. For today. I didn't want to go alone. I didn't know who else to ask.

DANIEL: Friends?

GERRY: Are we?

DANIEL: No I meant – (*Realises GERRY is desperately looking at him.*) Sure. (*Beat.*) You must be relieved

GERRY: Of course…to be accused of hurting someone that you love…

DANIEL: What's it like? Watching a person die?

GERRY: You watched people die

DANIEL: That was different

GERRY: Why?

DANIEL: I had no choice

GERRY: She had tried it before and I just happened to walk in. (*Beat.*) I didn't know what to say only 'you're doing it wrong, if you do it like that you won't kill yourself you'll just blow the front of your head off and you could live like a vegetable for years.' (*Beat.*) She put the gun down, pushed her hair out of her face and said 'thanks' and we had tea and didn't mention it. Then maybe a year on…she wasn't getting any better and I was so involved with work I hadn't really noticed so when she asked me to help her (*Beat.*) I said 'what are you thinking? No, of course. No'… but not because I didn't want to help her, because she wasn't always so…unhappy…wasn't always…you weren't always so unhappy. (*DANIEL looks at him.*) But then… I experienced something I wasn't expecting…a phase…a momentary lapse of concentration (*He drifts off…stops talking suddenly and stares into space.*)

DANIEL: What kind of lapse…?

GERRY: (*GERRY looks at him like he had forgotten he was there.*) Yes a lapse…and when I got home that evening she made me my favourite meal and we had wine and over dessert she asked me 'Do you love me?' and I said 'Of course I love you' and then she said…she just said 'So help me'. Just like that…and the way she looked at me…the way you just looked at me… (*Beat.*) And I said yes. Just like that. Just yes. (*Beat.*) How do people change…so much…how can they be one person one month…one day…and then be something else entirely? And how are you supposed to love both sides? What if you love one side? The side you fell in love with and what if the other side…is like a stranger? What then?

DANIEL: Or what if you want to love someone because you know it would make them happy and it might even make you happy but you just don't feel that way?

GERRY: (*Looks at him.*) That's completely different

DANIEL: No it's not…it's the same thing…it's guilt. (*Beat.*) I dream in guilt…last night I dreamt I saw them walking through the rooms at the gallery…looking at the pictures… one girl I remember seeing on the bus…she was holding her head in her arms…cradling it like a baby…walking from piece to piece looking for herself. But I didn't use her picture (*Beat.*) Her family didn't want me to. (*Beat.*) So she couldn't find her face (*Beat.*) If I wanted to do it, end it, would you help me?

GERRY: (*Looks at him, laughs.*) You must be kidding, you? You? You?

He laughs again.

DANIEL: What? What's so funny?

GERRY: It's not enough

DANIEL: Not enough what?

GERRY: Pain

DANIEL: How can you measure pain? (*Beat.*) I thought you wanted to help people

GERRY: I do

DANIEL: So why aren't you helping me? You helped David Wrixon. (*GERRY squirms, it dawns on him.*) Oh my God... did you? Did you...help him? (*GERRY drinks from the bottle.*) They said it was an overdose

GERRY: He never knew who he was going to be in the next ten seconds...

DANIEL: He was...a genius

GERRY: Some people just do not get better, they're simply not able and David was suffering, life had become torturous, he simply couldn't do it anymore (*Beat, looks at DANIEL.*) But I look at you and I see... I see...youth...and life...

DANIEL: I don't –

GERRY: I'm the one who's falling apart. You know I'm seeing things? (*Beat, looks at DANIEL.*) Buildings, sky scrapers, bridges, suspended in air. Just hanging there. (*Beat, long beat, he shuts his eyes.*) Oh I want to go back, take those words back and just...talk...say something else...say other words and hold you and make love to you there on the floor and find that part inside you...the part that I loved... as if somehow me in you would make you whole...as if together we were one full thing instead of two...pieces.

DANIEL stands, GERRY looks at him.

DANIEL: Are you speaking to me?

GERRY: (*Breathes more than says it.*) I'm speaking to her.

DANIEL: She's not here

GERRY: How do you know?

DANIEL: Because... I can't see her (*Beat.*)

GERRY: Hold me

DANIEL: What?

GERRY: Hold me

DANIEL: Who is helping who here?

GERRY: You like girls Daniel?

DANIEL: What?

GERRY: I used to love girls, all shapes, tall ones, small ones, fat ones, red hair, green eyes, black skin, freckles… (*Beat, stands up, drunk swaying.*) You think the dead can hear us? (*Beat.*) All the dead souls, with their dead ears, pressed against the thin veil between life and…and…whatever it is that's after…life. Christ, now she knows when I was lying and wasn't that often? My god, did I ever tell the truth? My head hurts, come and put your hands on my forehead, sit behind me and wrap your legs around me (*Beat.*) No matter what you think or what you see now that you could not see before (*Beat.*) I did love you (*Beat.*) I did. (*Beat.*) Once (*Beat, he falls down.*)

DANIEL: I want you to help me, I want you to help me like you helped David

GERRY: No

DANIEL: This much pain Gerry, this much pain is enough

GERRY: No, I won't do it. I won't.

DANIEL: Fine. (*Beat.*) I don't need you. I'll do it myself.

He exits, GERRY stares after him, he picks up the camera.

SCENE FOURTEEN (I)

Wasteland, as before. A long table with a hospital trolley/bed on wheels. There are boxes here and there, plastic cups and bottles of sparkling wine etc. LJ enters with a box on her lap, she pushes her way to the table and lifts the box on to it. She opens it. Takes out a series of knives, different

sizes and shapes, she looks at them curiously then lays them out on the table. DANIEL enters with another box.

LJ: I wasn't sure…how you wanted these done

DANIEL: Laid out flat… I have more here

LJ: (*She watches him lift more knives from another box.*) Why did you have to bring knives?

DANIEL: It's part of it, you'll see

LJ: I was so glad when you called, the things I said… I shouldn't have said them… I shouldn't have

DANIEL: But they were true?

LJ: No

DANIEL: You stayed on the bus because of me.

LJ: (*Doesn't know what to say lifting out more knives.*) Who's coming tonight? (*DANIEL doesn't answer.*) It's for that woman isn't it? All of this, it's for her?

DANIEL: Michelle, she is an important part of it yes

LJ: What do you expect her to do?

DANIEL doesn't answer.

DANIEL: She lost someone…they all did…and I'm here and I'm fine…and I want them to know… I want to give them the chance…

LJ: The chance to what?

DANIEL: You said you'd help

LJ: I am but –

DANIEL: That's what you said and I know it's asking a lot but I won't ask for much more, I promise. Okay?

LJ: (*Beat.*) Okay. (*She lays out more instruments, she takes out more knives, then a gun.*) Where did you get this?

DANIEL: (*Beat.*) It's not real…

LJ: It looks real… (*She takes bullets from the box.*)

DANIEL: (*Taking the gun off her.*) Look if you want to go –

LJ: No…no I don't want to go… Danny talk to me…please… what are you doing this for?

DANIEL: I just need you both to be here… I owe you

LJ: You don't owe me anything, I wish I could take it back, I would take it back if I could I would –

DANIEL: Doesn't matter now. What's done is done. Will you help me with the rest of the boxes?

DANIEL exits, LJ follows.

(II)

Warehouse. KARL and STEPH arrive, STEPH looks upset and has buttoned her jacket right up to the neck.

KARL: (*Drinking from a bottle in a brown paper bag.*) I never said they wouldn't ask you to do that so just…give it a rest

STEPH: You never said…of course you never said…if you said that that's what they wanted me to do I wouldn't have gone…what you think that's the type of girl I am? I'm not taking my top off for anyone. You told me it was a singing audition

KARL: There is some singing involved…look I was only trying to help you along…give you a hand up

STEPH: You call that a hand up?

KARL: Well it's a video isn't it? You said you wanted to be on camera?

STEPH: As a singer Karl…not as a…as a…that's pornography is what that is

KARL: It's not porn, it's pretending, with porn you actually have to do it, and so what if it was? You know that porn makes more money every year than Hollywood...like fifty times over or something

STEPH: It's not about money

KARL: Sure it's not

STEPH: It's not... I'm a singer... I can sing

KARL: Most everyone I know can sing... I can sing...that doesn't mean anyone wants to hear me do it

STEPH: (*Beat.*) You think people don't want to hear me sing?

KARL: I'm just saying...look....you said you wanted to make some money...get out of your brother's place...get your own pad...those guys would have given you eight hundred for one day's work

STEPH: And you wouldn't care? If I slept with other people? (*He goes to correct her.*) If I pretended to sleep with other men? Have someone else touch me? For money? (*Beat.*) On camera?

KARL: (*Beat, looks at her, bothered all of a sudden.*) Why do you have to put it like that?

STEPH: (*Beat.*) Look I know you're disappointed about your invention but –

KARL: I don't give a toss about that. It's a stupid fucking idea anyway and I told you that and then you went and made it seem like it wasn't and then I end up looking like a fucking idiot

STEPH: Wasn't your fault someone else had made it already –

KARL: I said I don't fucking care about that (*Beat.*) This isn't about that... (*Beat.*) I don't know what you think is going on here sunshine but... I'm not exactly a one woman guy

STEPH: (*Beat.*) Thing is…if we're not exclusive…if you're seeing these other girls…how come you've been with me every night the last six weeks?

KARL: (*Looks at her.*) You know…you're just…you're just giving me a headache now and I didn't come all the way out here with you to get a fucking headache alright? (*Beat.*) Where is he anyway? (*Picks up one of the knives, STEPH isn't responding, he turns and looks at her.*) Look…look I know… I know I can be a bit…rough sometimes but… I do like you… I don't know why but I like being around you and I don't usually like hanging out with girls once the…the…

STEPH: Physical side?

KARL: Yeah the physical side…but you're…you're alright

STEPH: (*Beat.*) You shouldn't have brought me there, you shouldn't treat people like that, me like that

KARL: Okay I shouldn't… I'm…look I'm… I'm sorry…see I said it…and I never say it

STEPH: So you do mind if I…if I go with someone else?

KARL: I mind…alright? I don't want you saying it anymore… don't like thinking about it… (*STEPH smiles but KARL looks bothered.*) I don't like feeling like this…worrying about someone else

STEPH: You worry about me?

KARL: Can we stop talking about it? (*He drinks from the bottle then hands it to her, spots the gun, he takes it.*) Wanna go outside?

STEPH: What for?

KARL: So we can shoot this

STEPH: (*Shocked but more fascinated than afraid.*) Where did you get that?

KARL: On the table

STEPH: Is it real?

KARL: 'Course it's real…want to have a go? (*STEPH shakes her head.*) Go on…just hold it…go on…just take it… (*STEPH takes it hesitantly, she is surprised, she likes how it feels in her hands, she giggles.*) You like it? (*She nods, she strikes a Charlie's Angels pose and flails the gun about, KARL ducks.*) Woah…take it easy…

STEPH: Sorry

KARL: That's okay… (*Takes it back.*)

STEPH: What you going to do with it?

KARL: Take it outside…maybe there's some rats around here…or some dogs…

STEPH: You wouldn't shoot a dog?

KARL: No…'course not… I was just kidding… (*They exit.*)

(III)

DANIEL is lying on the hospital bed, LJ is drinking sparkling wine from a plastic cup.

DANIEL: She's not coming is she? Nobody's coming.

LJ: (*Beat.*) Maybe she couldn't handle it

DANIEL: Handle what?

LJ: The whole thing…the concept of it…maybe it was just too much

DANIEL: But she didn't have to…to do anything if she didn't want to…we could have just…talked

LJ: Maybe she didn't want to (*She wheels towards him.*) Maybe she is dealing with what happened to her the best way she knows how

DANIEL: But it would have helped…it could have

LJ: Maybe (*Beat, she looks at a video camera on the table.*) You want me to switch it off?

DANIEL: Leave it...

LJ: Alright (*DANIEL looks at her, she pours more wine into her cup.*) What?

DANIEL: You were there

LJ: Huh?

DANIEL: You were there, on the bus, you were there

LJ: Yeah I know, what you on about?

DANIEL: You only stayed on because of me and I know you feel resentment...towards me?

LJ: No

DANIEL: You do, you said so

LJ: I didn't mean it, I was angry with you

DANIEL: You must...no one could go through what you've been through and not feel...anger...resentment...regret

LJ: I'm trying to forget about it actually

DANIEL: How can you forget about it? You're reminded of it everyday...every fucking day

LJ: Stop

DANIEL: Your legs

LJ: Stop

DANIEL: It's ruined your life... I've ruined your life and I'm here and I can walk or run or –

LJ: (*Yelling.*) Stop! (*DANIEL looks at her in surprise.*) Just shut up will you, what you trying to do? You want me to stick a knife in you just so you can feel better about yourself? (*DANIEL looks away.*) You think I don't know that you

can walk and I can't? (*Beat.*) You think everything hasn't become about the fact that other people can do things I can't?

DANIEL: (*Beat.*) Please

LJ: No

DANIEL: (*He takes a knife and walks towards her.*) Please

LJ: No

DANIEL: Please

LJ: No

DANIEL: Please please please please please please please please please please (*LJ puts her hands over her ears.*)

LJ: Stop

She choses a knife, she is shaking, He rolls up his sleeve, she is shaking so much now she can hardly hold the knife. She touches his arm, lets the tip of the knife rest on it, she is upset, he hardly seems to notice, is intent on her cutting him. She does it, cuts a straight line, he bleeds, she drops the knife. He seems relieved, he watches the blood.

LJ: I'm sorry

DANIEL: What for?

LJ: (*Beat.*) Come here (*She hugs him, LJ doesn't want to let go.*) I think you're fucking brilliant, you're like no one I ever met before, ever saw before (*DANIEL tries to pull back but she holds him tight.*) And what do you think of me? (*He tries to pull back.*) No just stay like this, tell me like this (*Beat.*) What do you think of me?

DANIEL: (*Beat, he is uncomfortable in the embrace.*) I... I... I think you're brilliant too

LJ: Do you think I'm pretty?

DANIEL: (*Beat.*) Sure

LJ: You ever think of me that way?

DANIEL: Why are you –

LJ: You ever think of me that way? (*DANIEL pauses, then pulls away, shakes his head.*) Right…okay… (*Beat.*) would you have before? (*Beat.*) Before…would you? Be honest

DANIEL: (*Beat.*) I don't know…

LJ: That's it is it? That's all I get? I don't know? (*She looks down, long beat, DANIEL goes to say something.*) Please don't…please just…can you leave me alone for a few minutes?

DANIEL: But –

LJ: I'd like to be on my own for a few minutes

> *DANIEL exits holding his arm. LJ stares after him. After a moment, KARL and STEPH enter, drunk.*

STEPH: Where is everybody?

LJ: They didn't show

STEPH: What no one?

LJ: No one

KARL: Nice to see you again (*LJ drinks more wine.*) some fucking party this is then

STEPH: Where is he? Is he alright?

LJ: In the back

> *STEPH looks at KARL who is staring at LJ, she exits.*

KARL: (*Chooses a bottle of champagne and opens it, he sits on the bed and stares at LJ.*) I figured it out (*LJ looks at him.*) How I know you…or where I know you from…just…didn't recognise you with your clothes on is all

LJ: Thought you looked familiar

KARL: I should hope so…left the best part of a hundred pounds in your knickers one night if I remember correctly…you remember that night? My birthday? I had a private room?

LJ: No

KARL: Occupational hazard I'm sure

LJ: Never heard that one before

KARL: Must be horrible…girl like you…looking like you did (*She looks a away.*) Cocky too…that's why you did so well I'm sure…men like that…attitude…balls

LJ: Men like a woman with balls?

KARL: Cheeky (*Beat.*) I offered you another hundred that night…you had me so worked up…remember? Said I'd give you two when you turned me down…

LJ: I turned a lot of men down

KARL: Not anymore (*LJ looks away.*) I'm just kidding…sorry… bad taste…you're still an attractive girl (*Beat.*) I saw you… watching me…that night at Steph's…what you watching me for?

LJ: I wasn't

KARL: You were…this time I had you all worked up didn't I…

LJ: Fuck you

KARL: You'd like to

LJ: In your dreams

KARL: In yours (*LJ looks at him.*) Come here

LJ: No

KARL: I'm not going to bite you…come here?

LJ: What for?

KARL: Just…come…here (*She doesn't, he moves towards her instead.*) What would you say if I told you you could…right here…now? (*Beat.*) You afraid they'll come back and see?

LJ: You'd do that to her?

KARL: Doesn't own me. Come on

LJ: No

KARL: Why not? I mean we're both adults here…no strings attached or nothing…just sex…don't you want to have sex LJ?

LJ: Not with you

KARL: Yeah…sure…who else is going to do it with you…might be a while… I'm doing you a favour and not many people would be as generous…you know there's nothing out there for people like you and me…just closed doors…need to stick together…people like us

He pulls her chair towards him, she seems almost frozen, he kisses her.

LJ: Stop (*He kisses her more forcefully, grabs at her breasts roughly.*) Stop (*But she doesn't really mean it, she's lost, this continues as they speak, becoming more frantic. STEPH appears and watches.*) Not here

KARL: Outside? (*LJ nods.*) Well come on

He moves to go, she follows slowly. STEPH watches them exit.

(IV)

STEPH is sitting on the hospital bed holding a knife. She traces the tip of the knife back and forth over her forearm. She has a wine bottle balanced somewhere .

STEPH: I am special, I am precious, I am special, I am precious, I am. (*GERRY enters, he looks terrible. He clears his throat.*) You might as well just go because you've

been treating me like…like shit and it's not right to treat someone like shit because then you…then you…

GERRY: Sorry?

STEPH: Oh no… I'm sorry… I thought you were… I thought you were… (*Beat.*) Oh, you must be here for the show…for Danny's show

GERRY: Yes (*Beat.*) Have I missed it?

STEPH: Nobody turned up. Well. Except you. At least one person turned up. That might cheer him up. He's recording out the back, you want me to go get him?

GERRY: No that's alright, I'm sure he'll…be along

STEPH: Are you a parent of one of the people who died?

GERRY: No… I'm just… I'm a friend of Daniel's

STEPH: (*Relieved.*) Oh right…oh…well… I'm Steph

GERRY: (*Shaking her hand.*) Gerry

STEPH: He's probably mentioned me to you (*GERRY thinks.*) I'm his sister? Well his half sister (*Beat.*) He never mentioned me?

GERRY: I'm sure he did… I'm very forgetful

STEPH: Yeah (*Beat.*) Actually you look kind of familiar (*GERRY goes to say something, she cuts him off.*) No don't tell me, I bet you're an actor or someone off the telly?

GERRY: No

STEPH: I know (*Beat.*) Of course (*Beat.*) You look like Danny's dad…well like the photo I saw…kind of…it's your eyes I think…you have nice eyes

GERRY: Thanks

STEPH: I always wished I'd gotten my dad's eyes but I got my Mum's…not that her eyes aren't nice, just that, well, the

fact that he's dead, makes it seem like it would be more exciting to have looked like him…that's stupid isn't it? Stupid

GERRY: It's not stupid. We met at Danny's show, that's probably why I seem familiar

STEPH: Oh… I remember…sure (*She smiles, beat.*) You still remind me of Danny's dad though. You know Danny's dad and my dad were different people, but they both died, and then my mum met someone else and then he died…so it's like I had two dads and Danny had three…and they all died…so I guess we kind of gave up on the idea of having a dad. (*Beat.*) But Danny… Danny was always such a great guy… (*She's drunk, exaggerating everything.*)…always…doing things for people…and I tried… I mean I still do try to do things for him but…you know… I don't think I'm very good at it. (*Beat.*) I helped him once though…we were down at the lake…did he tell you about the lake? (*GERRY shakes his head.*) Oh it's beautiful…we used to go down there all the time…just the two of us…swimming…we had such great times. But this one time Danny went under and I was counting…you know…timing him…and he must have been under…like…for minutes…minutes and minutes and I went looking for him…and he was just lying there…at the bottom of the lake…just lying there with his eyes closed (*Beat, she gasps.*) Oh… I did get a bit of a fright then… I thought maybe he was…dead…but he wasn't he was just playing…and I pulled him by the arm (*She gets a bit upset.*) but he was stuck…and he couldn't budge and I just pulled and pulled and pulled and then he opened his eyes and looked at me and I said (*Change of tone completely, very upset and frantic.*) Get up Danny, get up, you're scaring me and my chest hurts now get up. (*Goes back to narrating it.*) and he did. So I helped…once. (*Beat.*) Danny loves me. (*Beat.*) He's the only one who thinks I can do something…something special…succeed in something. (*Beat.*) I'm going to be a singer, had an audition today and it…it went really well…went fucking magic actually…said I

had something…that something that you need to be a pop star…said I was…punchy…that's it…went really well. (*She stands but almost falls, drops the knife.*) Why do people use people? Just to make themselves feel better? Is that it? How can making someone feel like shit make you feel better? (*Beat, she puts her head in her hands.*)

GERRY: I don't know

STEPH: I saw the saddest thing today, (*Beat.*) this dancer…fell from a window right across the road and she died…isn't that sad?

GERRY: Yes

STEPH: And she was wearing this beautiful costume… white…feathers…she looked like a little dead bird on the pavement (*Beat.*) So sad (*Beat.*) I wanted to go over to her and shake her and wake her up and tell her she can't die… beautiful things shouldn't be allowed to die because they make you feel…better…less sad (*Beat.*) Why is everything so sad? I don't want to be sad I want to be happy (*Beat, she puts her head in her hands.*)

GERRY: Then be happy. (*She looks at him.*) Happiness takes time and effort, you have to treat yourself like a very precious object, an object that you wouldn't place in harm's way, that way you are in control of your own happiness

STEPH: And that's all I have to do?

GERRY: Well it's a start…

STEPH: Alright. Now what?

GERRY: Now you should take my taxi and go home, he's waiting outside

STEPH: Really?

GERRY: Go home (*Beat.*) things will seem better in the morning

STEPH: You'd be a good Dad…looking after me…what dads do isn't it? (*Beat, she stands.*) I should go say goodbye to the others (*Beat.*) But you know I don't quite feel like it

Takes her bag and her jacket and exits. GERRY looks at the items on the table, he picks up the knife that STEPH has dropped and looks at it, tests it's sharpness, cuts his finger, sucks it. DANIEL enters carrying a camcorder, he is surprised to see him.

DANIEL: This is only for friends and families who have lost someone

GERRY: I lost someone

DANIEL: Who lost someone in the accident. (*Sees the knife in GERRY's hands.*) Give that to me

GERRY: (*Considers it, then puts it behind his back.*) No

DANIEL: No? What do you mean no?

GERRY: No

DANIEL: Give it to me

GERRY: What's with the knives anyway?

DANIEL: None of your business, I want my knife back (*GERRY looks at the table and takes another knife and puts it behind his back.*) What are you doing?

GERRY: I want you to listen to me first

DANIEL: Or what? You'll steal my knives? This is ridiculous, keep them, I don't care, I have plenty more (*GERRY takes a small container from his pocket and holds it up in 'ta da' fashion.*) What?

GERRY: Sodium pentobarbital, the suicide drug.

DANIEL: For me?

GERRY: No actually…for me… I was planning on killing myself tonight and I was wondering if you wanted to film it…

DANIEL: If anyone is killing themselves tonight…it's me

GERRY: (*Picks up a bottle and takes a drink.*) I don't want to live anymore

DANIEL: Me neither

GERRY: I'm in too much pain.

DANIEL: Me to.

GERRY: Fine

DANIEL: (*Less sure.*) Fine

GERRY: (*Beat.*) I helped my wife to die (*Beat.*) I thought it would solve some problems, and it did, but it made more problems.

DANIEL: I have my own problems.

GERRY: I'm hallucinating

DANIEL: I'm depressed

GERRY: I helped people kill themselves

DANIEL: I walked out in front of a car yesterday (*GERRY looks at him.*) It swerved but I still did it

GERRY: I killed my wife

DANIEL: I can't compete with you…you killing people…

GERRY: (*Beat.*) Let me do this…please… I can't bear it… I can't bear to be left like this… I'm hallucinating for God's sake…have been for weeks

DANIEL: Stop saying that…didn't you see it…in the paper? Those…those towers you saw…in the sky?

GERRY: What about them?

DANIEL: Something to do with thermal structures in the air above the water

GERRY: You're lying

DANIEL: Why would I lie?

GERRY: Because…because…you're afraid I'll steal your thunder

DANIEL: My thunder? What are we in the eighties?

GERRY: Doesn't matter…doesn't… I still want to die… I may not be unwell but I'm… I'm…

DANIEL: What?

GERRY: (*Quietly.*) I'm gay

DANIEL: So?

GERRY: So? So? I can't be gay, are you insane? How can I be gay? I had a wife for twenty years, I've had girlfriends my whole life, I can't be gay

DANIEL: Why not?

GERRY: Because its not who I am it's not who I know myself to be…because it makes the time I spent with her seem false and it wasn't false…it wasn't…

DANIEL: You can love more than one person

GERRY: (*Beat.*) I don't want to. This is for her (*He takes the video camera he has around his neck and turns it on.*) hold it

DANIEL: No

GERRY: Fine (*As he talks he sets it down on the table and focuses it on himself, then he takes the container out of his pocket and pours a glass of water, DANIEL is watching him carefully.*) Now I have a speech so if you don't mind being quiet while I…you know… (*Clears his throat.*) It's so difficult to know what to – (*DANIEL grabs a knife and holds it to his own throat.*) What are you doing? Cutting your own throat is pretty impossible to do well…you could end up bleeding to death for hours…very painful…wouldn't recommend it…now this… (*Holds up the container.*)

DANIEL: Give me that…

GERRY: No

DANIEL: I said…give me that (*GERRY puts it behind his back, DANIEL lunges for GERRY, they struggle, wrestle about on the floor, GERRY overpowers DANIEL and pins him on the floor.*) Get off me…just get off me…get… (*GERRY hugs DANIEL very tightly.*) What's happening right now?

GERRY: It's alright (*Beat.*) It's alright.

DANIEL: It's not alright, its not. Nothing is alright. Nothing is the way it should be. (*Beat.*) Nothing is the way it was before. (*Beat.*) Everything is dark, everywhere I look there are only dark things and I just… I want to go back to the way it was before. I want to be on my dad's shoulders on the beach. I want to be happy. I want to be on that bus and I want it reach its destination. I want to be at the bottom our lake holding my breath and hear Steph calling me to come up for air. I want to come up for air.

GERRY holds him like a child, cradles him. We hear a loud gunshot. They both stop and stare. Lights fade down on them.

SCENE FIFTEEN

Lights up slowly to reveal an exhibition room. We hear the sound of a crowd murmuring nearby. GERRY wanders in and stops to look at the painting of the ship from earlier, without KARL's drawing. DANIEL enters

DANIEL: So what do you think?

GERRY: I like them

DANIEL: Really?

GERRY: Your paintings are beautiful

DANIEL: You staying for her piece?

GERRY: I'm not sure

DANIEL: She asked me to use it. She told me to. (*Beat.*) But I don't know if that makes it any better. (*Beat.*) You been in to see her?

GERRY: No

DANIEL: They're deciding…about the life support machine… there's no guardian so it's the states decision and the state will decide to keep her alive. I visit her… I used to go every day but there's not much point… I'm not sure she knows I'm there.

GERRY: It was her choice

DANIEL: I know (*Beat.*) We should go through, it will be starting

GERRY: Don't think I'll stay, if you don't mind (*Reaches out to shake his hand.*) I would say that I will see you soon but I don't suppose I will and what's the point in lying to ourselves at this point?

DANIEL: Thank you…for helping me…or not helping me… whichever

GERRY: You're welcome (*He holds out his hand to DANIEL to shake.*) Good luck

They shake hands and hold until STEPH enters and the moment is broken.

STEPH: It's starting.

DANIEL stares GERRY for a moment.

GERRY: Goodbye

DANIEL drops his hand. GERRY leaves.

STEPH: Bye. (*DANIEL stares at the painting. STEPH stands beside him.*) I can see it now Danny, the ship, I can see the stern

Beat.

DANIEL: (*Looks at her like she might be his saviour after all.*) You want to go home for a while?

STEPH: (*Delighted.*) You mean it?

DANIEL: I think I'd like to go home for a while

STEPH: But everyone is waiting

DANIEL: Let them wait

Lights down on them leaving and up on a video screen projection of LJ on the back wall. She fumbles for a bit, trying to focus it on herself and then she sits back.

LJ: Hi...well...this is for Danny...this message (*Beat.*) I know you understand, what it feels like, to be alone. Difference is...you're not always going to feel like this...and it's unbearable (*Beat, upset now slightly, trying to stay smiling but fear and tears are gathering in her throat, she takes the necklace off and wraps it around her fingers.*) All I can think of these days is what it would have been like if you had come into the club one night, just came in, not because you like those sort of places but because you would have seen me somewhere...on the bus...the street...and followed me. I see you coming in and getting a beer and standing at the bar and me coming out looking just....just beautiful... stunning...and our eyes locking and me dancing for you...and you being... (*Smiles through the tears.*) dazzled... (*Beat, she shows us the gun in her hands.*) and this...this just makes sense...it came right to me... I didn't even think about it but yet it ended up right in my lap...what's for you won't go by you. And you can use this, I give you my permission, use it, use me (*Beat.*) because then it means something, doesn't it? It means something (*She lifts the gun, opens her mouth, puts the gun in, takes the gun out it.*) This is what I want... (*Beat.*) I should say it... (*I love you.*) I should...but...well... I guess you know it already... I guess I've made it pretty clear

In a fast movement she puts the gun in her mouth and fires. The film stops. In the distance, we see the silhouette of LJ. dancing for a few moments before it disappears into the darkness.

The End